The Picture in Question

The Picture in Question

Mark Tansey and the Ends of Representation

Mark C. Taylor

The University of Chicago Press / Chicago and London

Mark C. Taylor is the Cluett Professor of Religion and Humanities
and Director of the Center for Technology in the Arts and Humanities
at Williams College. His many books include *Erring: A Postmodern
A/theology; Deconstruction in Context; Altarity; Nots; Disfiguring: Art,
Architecture, Religion;* and *Hiding.* He is the editor of *Critical Terms for
Religious Studies* and coauthor/producer with José Marquez of *The
Réal—Las Vegas, Nevada,* a CD-ROM published by the Massachusetts
Museum of Contemporary Art and the Williams College Museum of
Art. Taylor is also director of the Critical Issues Forum for the
Guggenheim Museum.

The University of Chicago Press, Chicago 60637
The University of Chicago Press, Ltd., London
© 1999 by The University of Chicago
All rights reserved. Published 1999
Printed in the United States of America
08 07 06 05 04 03 02 01 00 99 1 2 3 4 5
ISBN: 0-226-79128-9(cloth)
ISBN: 0-226-79129-7(paper)

Library of Congress Cataloging-in-Publication Data

Taylor, Mark C., 1945–
 The picture in question : Mark Tansey and the ends of
representation / Mark C. Taylor.
 p. cm.
 Includes bibliographical references and index.
 ISBN 0-226-79128-9 (cloth : alk. paper). — ISBN 0-226-79129-7
(pbk. : alk. paper)
 1. Tansey, Mark, 1949–. —Criticism and interpretation.
I. Tansey, Mark, 1949– . II. Title.
ND237.T346T39 1999
759.13—dc21 98-34761
 CIP

For Louise Bremerman

Contents

Preface

On a late August afternoon in 1990 I was leaving the Media Lab at MIT, where I had spent the day exploring a future that was considerably nearer than I had realized. Still reflecting on the puzzles and possibilities of strange new cyberworlds and virtual realities, I stepped into an elevator and noticed a small poster for an exhibition of Mark Tansey's paintings in a nearby building. Rushing into the gallery only a few minutes before it closed, I was astonished by what I saw. Several years earlier, I had been intrigued enough by Tansey's pictures to use his *Doubting Thomas* on the cover of my book *Altarity*. While I had not studied his work in detail, I sensed then that his paintings pose many of the same questions that I explore in my writings. In the years after *Altarity* appeared, I began a sustained investigation of twentieth-century visual arts. For some reason, however, I lost touch with Tansey's work. When I rediscovered it at MIT, my earlier suspicions about the similarity of our preoccupations and trajectories seemed to be confirmed.

Though I do not remember all of the pictures in this small exhibition, two works made a lasting impression on me: *White on White* and *The Bricoleur's Daughter*. In addition to showing these paintings, Tansey exposed some of his strategies for picture making by displaying detailed preparatory studies for *The Bricoleur's Daughter*. With the gallery attendant announcing closing time and beginning to turn out the lights, I had

only enough time to cast a quick glance at these studies. What I found most fascinating was their inclusion of printed texts. In the midst of Tansey's collaged sketches and photocopies were heavily underlined and annotated passages from Plato, Lévi-Strauss, and, most extensively, Derrida. In the brief moment of my glance, I realized that Tansey and I were approaching similar problems from different directions. While I had been moving from a study of modern and postmodern philosophy to an examination of painting, Tansey had been extending his critique of modernist painting through an investigation of postmodern philosophy and criticism. Furthermore, the writers he found most helpful were, for the most part, the very same writers who had been guiding my work. Having seen this much, I knew I had to see more.

Repeatedly returning to Tansey's work during the past several years, I have continued to be impressed not only by the quality of his paintings but also by the care with which he reads and responds to different philosophical texts. Unlike so many twentieth-century artists and critics, Tansey realizes that representation and figuration are very complex and, in the final analysis, remain unavoidable. His sophisticated understanding of the Western philosophical tradition enables him to grasp the far-reaching implications of the artistic issues he so thoughtfully probes.

While pondering Tansey's paintings and reflecting on the problems they pose, I have begun to achieve greater clarity about my own work. Though the characters are not always the same, Tansey's paintings plot a story that parallels the philosophical and theological tale I have been developing for many years. Whether this story is mine or his, I do not know—nor do I think it matters. What I do know is that living with Tansey's pictures has opened new ways for me to think through old preoccupations. From my early studies of modern philosophy and theology in the writings of Hegel and Kierkegaard, through lengthy considerations of structuralism and poststructuralism, to more recent forays into chaos and complexity theory, I have found myself returning again and again to a single problem: the intricate interplay between temporality and representation in human existence. A paradoxical

problem in human life, I have long believed, is not how to overcome time but how to affirm its passage by embracing the arising and passing away that does not arise or pass away. *Nothing lasts* because all is in endless transition. Time, in other words, is the inescapable medium of our existence. For those with eyes to see, this wisdom is implicit in the disruptive faults and fissures as well as the turbulent cataracts and clouds of Tansey's most complex and provocative paintings.

It may be appropriate that a book devoted to the "end(s) of representation" should have no images. Nonetheless, when I initially proposed this study, I expected it to include representations of approximately thirty of Tansey's paintings. Tansey, for his part, agreed to collaborate by selecting for the book previously unpublished studies of some of his most important works, and we met twice to discuss the format of the book and to begin the process of deciding which studies would be most effective. In the months between these conversations and the completion of the manuscript, Tansey had a change of heart and refused to have any of his work reproduced. Though several personal and professional factors seem to have contributed to this about-face, the most interesting and substantive reason he offered was his fear that my interpretation would reinforce the widespread criticism of his work for being primarily illustrative. He repeatedly emphasized that he wanted to shift directions by moving from what he described as a top-down to a bottom-up approach that would allow the pictures to speak for themselves, and he asserted that the publication of my book would make it difficult if not impossible for people to appreciate this change in his work.

This unexpected turn of events is ironic. The ideas Tansey explores have always been my point of contact with his work, and over the years he and I have had many conversations about difficult theoretical issues. At times, indeed, it seemed to me that Tansey's painting and my writing mirrored one another in pursuit of the same philosophical problems. From my point of view, the distinction between a top-down and a bottom-up approach is specious. Furthermore, no picture speaks for itself, least of all when concept and image,

idea and representation, theory and practice are as inseparable as they are in Tansey's pictures. Claims to the contrary notwithstanding, Tansey, unlike some of his harshest critics, not only shares this insight but continues to explore its implications in his work. Of course, to stress the importance of a philosophical or theoretical interpretation of Tansey's art, as I do in this book, is not to deny the relevance of other accounts of his work.

For the convenience of readers who are not already familiar with Tansey's paintings, I have included a list of references indicating where reproductions of his work can be found. With the exception of one painting (*Transition Team*), all the pictures I discuss have been published in books or catalogs that are readily available. Many even circulate freely on the World Wide Web.

As I look back on that August afternoon eight years ago, Tansey's work now seems timely in new ways. What I saw on display at the Media Lab was a world in which reality and image rapidly become indistinguishable. When the virtual seems real and the real appears virtual, many artistic, philosophical, social, and political questions of representation assert their urgency anew. Far from avoiding or repressing representation, we must learn how to reconceive its ends by finding different ways to figure and refigure the complex networks that constitute the media of our lives. By putting the picture in question, Tansey forces us to confront issues that extend far beyond the painted surface of the canvas. The longer one studies his work, the clearer it becomes that, in a culture increasingly governed by images and representations, these pictures are not only good to *look at* but are also good to *think with*. To think with Tansey is to look at ourselves and our worlds differently. It is toward this end that the following pages are directed.

1 Picturing Painting

In 1984, Mark Tansey completed a complex picture entitled *End of Painting,* in which a cowboy stands in an empty room with six-shooters drawn, blasting away his own image reflected in a large mirror with a gilded frame. Like so many of his early works, *End of Painting* is as much art criticism as art. A painting about painting, this picture appropriates insights and strategies of leading postwar artists to criticize the foundational tenets of modernist doctrine. The picture is deliberately provocative. Bordering on illustration, the image depicted is resolutely illusionistic and implicitly narrative. It is as if Tansey were soliciting the return of what canonical modernism consistently represses. But as Freud, among others, has taught us, the return of the repressed is never a simple matter.

Tansey's critique begins with his title. In contrast to modernist painters who number their works or simply leave them untitled, Tansey regards titles as integral to paintings. His titles are not only *about* the work but are woven into pictures in a way that confounds any clear opposition between the visual and verbal aspects of the work of art. In this way, Tansey's titles *frame* his paintings.[1] *End of Painting* functions

1. As we shall see in more detail in what follows, the complexities of framing lie at the heart of Tansey's art. In this context, it is important to note that modernists not only tend to leave their works untitled but also

as something like a koan, which simultaneously provokes and shatters reflection. Does the title announce the conclusion of painting or identify the purpose, goal, and aim of painting? Is the title a play on the duplicity of "end" that suggests the goal of painting is the cessation of painting? Since there are no clear and decisive answers to such questions, the title remains a puzzle.

The question of the title carries over into the work. By shooting holes in the mirror and thus shattering his own image, the cowboy seems to destroy the regime of representation, which has governed painting at least since the Renaissance. But this gesture raises more questions than it answers. Does the broken mirror open a window on the thing itself? Or does the broken mirror expose the canvas that always veils the thing itself? What is reflection? What is representation? What does it mean to picture? Do pictures mean? By raising but not answering such questions, *End of Painting* puts the picture in question. As questions multiply, it begins to become apparent that Tansey is presenting an allegory of recent developments in painting through which he poses an inescapable question for every contemporary artist: Is it possible to paint after the "end of painting"?

In all his early work, Tansey relentlessly criticizes and satirizes the modern avant-garde. Stressing the military origin of the term "avant-garde," he repeatedly characterizes the inventors of European modernism as military figures engaged in advanced warfare. In *Triumph of the New York School,* for example, he depicts the shift of the center of the art world from Europe to America in terms of a military surrender. With loyal troops watching, a defeated André Breton and triumphant Clement Greenberg sign a peace accord. The devastation of the smoldering landscape that forms the background of the assembled armies indicates the price of "victory." More than the playing field has been leveled. When the avant-garde crosses the Atlantic, the legend of the European soldier gives

resist framing their works. The absence of the frame suggests the possibility of a direct, unmediated relation between the viewing subject and the art object.

way to the myth of the American cowboy. Mixing machismo and chauvinism, many postwar artists reflected and promoted growing American power at home and abroad. The so-called triumph of the New York School is not, however, unambiguous. As the cowboy-artist shooting his own image suggests, the wound painting suffers is self-inflicted. Painting negates itself in and through its own development. According to the story Greenberg and his followers plot, the end (i.e., purpose) of painting is the end (i.e., cessation) of painting.

But this tale is far too simple, for, as Tansey intimates, social and cultural forces beyond the art world influence the development of painting. *End of Painting* does not hang on the wall like traditional easel paintings but is mounted—perhaps projected—on a freestanding movie screen. The superimposition of painting on screen implicitly juxtaposes the crafty handwork of Tansey's painting with mechanically produced images of modernism and electronically reproduced images of postmodernism. Rather than opening onto the thing itself or another canvas, the broken mirror exposes a screen where painting gives way to film, video, and even virtual reality. Or so it seems. But the longer one ponders Tansey's work, the more puzzling it becomes. The cowboy-artist does not, after all, shoot *himself* but only his image. Yet (the) representation is not destroyed; both the painter and his figure are left standing. In a gesture characteristic of his signature works, Tansey suggests productive circuits of exchange between word and image. The drawn guns of the cowboy allude to the artist's act of drawing as well as to a context in which there are no clear winners or losers. Far from a conclusive showdown, this shootout ends in a draw; everything is left undecided. This undecidability creates the opening for Tansey's art.

Tansey came of age as a painter during a particularly fertile period in the history of postwar art. Casting a backward glance in 1989, he reflects:

My pictures began really as a result of . . . the death of painting in the mid-1970s. It was a time when the formalists' prohibition against representation seemed no longer to have authority and anything was possible

but the first problem or the problem that I was concerned with was what to do a picture of.[2]

Trying to figure out how to paint after the death of painting is like trying to find a way to write theology after the death of God. To many in the art world of the 1970s, painting seemed as nostalgic and retrograde as belief in long departed gods. The son of art history teachers, Tansey was introduced to painting as a teenager in classes at the San Francisco Art Institute. In 1967 and again from 1969 to 1972, he attended the Art Center of Design in Los Angeles where he studied with Lorser Feitelson, Lynn Foulkes, and Larry Dreiband. During the late 1970s, Tansey worked as an illustrator for the *New York Times,* the *New York Review of Books, Sports Illustrated,* and *GEO.* While most so-called serious artists and critics look down on illustration, Tansey discovered that it had important lessons to teach. Every bit as decisive as the exploration of various representational strategies and painting techniques was the theoretical questioning Tansey had begun while pursuing graduate work in studio art at Hunter College (1974–78). In courses he took with Rosalind Krauss, he was introduced to the rigors of philosophical criticism and critical theory. More than any other critic, Krauss is responsible for having introduced the contentious debates between and among structuralists and poststructuralists into the staid and stodgy world of art criticism. For a discipline frequently satisfied with debating questions of attribution and tracing lines of historical influence, Krauss's philosophical reflections and theoretical criticism were a breath of fresh air to some and irrelevant or even counterproductive to others. Tansey was intrigued by the questions structuralists and poststructuralists

2. Patterson Sims, *Mark Tansey: Art and Source* (Seattle: Seattle Art Museum, 1990), p. 4. Hereafter references to this work are given in the text as AS. While pictures can, of course, take many forms, it is important to note at the outset that there is a suggestive etymological association between "picture" and "painting." The word "picture" can be traced to the Latin *pictura,* which, in turn, derives from *pingere* (to paint). The stem *peig* means to cut or mark by incision. In what follows, we shall see that the connection between painting and cutting opens fertile lines of communication between painting and writing.

raised and quickly became immersed in and conversant with their complex ideas.

In order to appreciate the importance of theoretical questions for Tansey's work, it is necessary to have some understanding of the philosophical background of the debates that dominated literary and art criticism throughout the 1970s and 1980s. Even the most cursory consideration of Krauss's writings indicates the impossibility of engaging her criticism without coming to terms with the position of her teacher, Clement Greenberg. The most eminent critic of his generation, Greenberg not only influenced the interpretation of art but perhaps more importantly also had a significant impact on the kind of art produced in postwar America. Greenberg's criticism is less descriptive than prescriptive or, more precisely, proscriptive. Never content merely to inform readers about what artists are doing, his aim is to tell artists what they *ought* to do and readers what they *ought* to see. In his highly influential 1960 essay "Modernist Painting," Greenberg offers what has become the canonical definition of modernism for many artists as well as critics.

> The essence of Modernism, as I see it, is in the use of characteristic methods of a discipline to criticize the discipline itself, not in order to subvert it but in order to entrench it more firmly in its area of competence. Kant used logic to establish the limits of logic, and while he withdrew much from its old jurisdiction, logic was left the more secure in what there remained to it.[3]

By arguing that Kant's critical philosophy defines modernism, Greenberg privileges the notion of autonomy in his interpretation of art. While Kant's account of autonomy is unusually complex, two of its fundamental features are crucial in this context: self-determination and self-referentiality. Autonomy first and foremost involves self-determination. Whether considered in relation to free will or critical reflection, autono-

3. Clement Greenberg, "Modernist Painting," *Modernism with a Vengeance, 1957–1969,* ed. John O'Brien (Chicago: University of Chicago Press, 1993), p. 85.

mous activity, Kant maintains, is determined by nothing other than itself. In Greenberg's definition of modernism, for example, a discipline constitutes *itself* by using *its own* methods to establish *its own* limits. Extending Kant's critical method, Greenberg argues that every art is autonomous. Each form of art, in other words, is characterized by a distinctive method and *should not* contaminate or allow itself to be contaminated by other arts. No longer determined by anything other than itself, autonomy becomes actual in the splendid isolation of self-related works of art.

While Greenberg's insistence on the autonomy of different arts is widely acknowledged, the relation between his view of self-critical artistic method and the substance or content of modern painting is rarely recognized. Though he never draws the connection explicitly, self-determination entails self-referentiality. That which is determined by itself refers to nothing beyond itself or refers only to itself. For this reason, self-referentiality is the structural foundation of the autonomy that Greenberg regards as both the proper method and true content of modernist painting. Referring to nothing beyond itself, art is essentially about art. Greenberg, unlike Tansey, draws a sharp distinction between representation and figuration by limiting the former to imitation or mimesis. From this rather simplistic point of view, representation is virtually indistinguishable from direct illustration. Since representation always points beyond itself to that which it is supposed to re-present, representation is not self-referential but is about something other than itself. Figuration, by contrast, can be self-referential and thereby both abstract and non-representational.

The notion of self-referentiality defined by Kant and elaborated by Hegel lies behind Greenberg's interpretation of flatness, which he sees as the unique domain of painting. While sculpture explores three-dimensional space, painting is insistently two-dimensional. To achieve flatness, every trace of illusion must be overcome. The ideal of flatness, therefore, involves an endless effort to remove representation or to render representation nonreferential by transforming it into abstraction. When representational painting creates illusions, it

is deceitful, deceptive, dishonest; in short, representation is untruthful. Abstraction, by contrast, is direct, honest, immediate, and thus truthful. To surmount error and reach truth, it is necessary to strip away illusory representations and uncover the thing itself. As representations fade and the flat surface of the painting comes into focus, the experience of what Greenberg labels "opticality" becomes possible. Opticality involves the immediate enjoyment of the surface as such. In this moment, object and subject become one. Like the self-referential work of art, this immediate visual experience points to nothing beyond itself.

As I have suggested, Greenberg's criticism is not only descriptive but is also prescriptive and proscriptive. His normative assessment of the relative value of representation and abstraction serves as the basis of his interpretation of the history of art. According to Greenberg, artistic development is not random but is a teleological process in which there is "progressive" movement from representation to abstraction. The goal of art, in other words, is to end representation. While "primitive" art tends to be representational (even when it is abstract), "modern" or "advanced" art is formal or abstract (even when it is figurative). By advancing from representation to abstraction, one moves from deceit, deception, and dishonesty to truth. From this point of view, the history of art is a slow process of purification that culminates in the self-determination and self-referentiality of modernist painting. "Thus would each art," Greenberg concludes, "be rendered 'pure,' and in its 'purity' find the guarantee of its standards of quality as well as its independence. 'Purity' meant self-definition, and the enterprise of self-criticism in the arts became one of self-definition with a vengeance."[4] If abstraction is pure, then representation would seem to be impure. But why is Greenberg so suspicious of representations? Why do representations contaminate, pollute, and corrupt? Why must representation be repressed?

Greenberg's suspicions about representation are the product of a long philosophical and theological tradition. From

4. Ibid., p. 86.

Platonic formalism to Jewish monotheism and Protestant puritanism, iconophobia runs deep in the Western tradition. Beyond the prohibition of images expressed in the Second Commandment, the most influential critique of representation is developed in book 10 of Plato's *Republic*. Virtually every subsequent critic directly or indirectly echoes Plato's argument. Plato organizes his criticism around two closely related points: first, representations are deceptive or untruthful; and, second, representations appeal to sensuous emotions, which threaten to overwhelm reason. Plato's misgivings about art presuppose an understanding of representation as essentially mimetic. Images—be they verbal as in poetry or visual as in painting—claim to re-present things by imitating reality. The artist is, however, at best ignorant of the truth he claims to represent or at worst a "magician" or "trickster" who intentionally deceives by passing off appearances for reality. The truth of things, Plato believes, is their eternal form, which transcends the realm of sense experience and is only available to pure reason. The power of art in general and painting in particular lies in what Plato, through Socrates, describes as its "appeal to the inferior part of the soul." The painter, like the mimetic poet, "sets up in each individual soul a vicious constitution by fashioning phantoms far removed from reality, and currying favor with the senseless element that cannot distinguish the greater from the less, but calls the same thing now one, now the other."[5] By engaging the emotions, representational art threatens to seduce reason. Since Plato is convinced that sensuous emotions engender psychological distress and provoke social unrest, he insists that personal happiness and political order require freedom from mimetic representation.

Anticipating Greenberg's interpretation of representation, Plato charts a process of purification that culminates in the rational comprehension of absolute ideas, which are uncontaminated by any trace of materiality or sensibility. When knowledge is pure, it is no longer mediated by material em-

5. Plato, *Republic,* in *The Collected Dialogues,* ed. Edith Hamilton and Huntington Cairns (Princeton, NJ: Princeton University Press, 1971), p. 830.

bodiment and sensuous awareness but is the direct and immediate apprehension of the ideas as such. The movement from the appearance of representations to the truth of ideas involves a progressive disentanglement from time and a steady approach to eternity. This process culminates in the perfect union of subject and object, which marks the ecstatic moment when time becomes eternity.

Plato's philosophy has had an enormous influence, sometimes direct, often indirect, on the interpretation of art. The thinker who has played the most important role in transmitting Plato's legacy in a way that shows its lasting relevance for modern and postmodern art is Hegel. By weaving together Platonism, Christian theology, and Kantian philosophy, Hegel creates a speculative vision that implicitly continues to inform art criticism and practice. Hegel, in effect, provides the basic outline for Greenberg's account of the development of art by historicizing Plato's analysis of the relationship between sensuous representations and rational concepts. According to Hegel, art, religion, and philosophy express the same truth in different ways. While art and religion embody truth in representations (*Vorstellungen*), philosophy articulates concepts (*Begriffe*) through which truth can be fully comprehended. Art, religion, and philosophy undergo a long complex historical development in which representation wanes as conceptualization waxes. Throughout his system, Hegel translates Plato's ascent from the darkness of temporal flux to the pure light of eternity into a historical dialectic through which consciousness gradually moves from sense experience to conceptual reflection. In contrast to Plato, for whom art is an illusion that must be dispelled for truth to appear, Hegel insists that art, though incapable of presenting truth adequately, is nevertheless a necessary moment in the emergence of consciousness. Philosophy brings art to completion by rendering explicit the rational concepts that remain implicit in sensuous representations. For Hegel, as for Plato, reason is the end (i.e., the goal and termination) of representation.[6]

6. Hegel derives the structure of his entire philosophical system from his imaginative reading of Kant's analysis of the beautiful work of art in

With this background in mind, it is possible to under-
stand several of the major tendencies of postwar art that are
crucial for Tansey's work as both extensions and reversals of
Hegel's argument. While Hegel translates art into philosophy,
certain artists, in effect, translate Hegelian philosophy into art.
This is not to suggest, of course, that artists deliberately bor-
row ideas from Hegel. Nonetheless, the movement from Ab-
stract Expressionism through Minimalism to Conceptualism
repeats Hegel's dialectical analysis of the transition from sen-
sation to reason and representation to concept. As we have
seen, Greenberg interprets the history of painting as the pro-
gressive movement from the illusionistic three-dimensional
space of representation to the flat two-dimensional surface of
abstract art. In the course of development from representation
to abstraction, art ceases to refer to anything beyond itself and
thereby becomes completely self-referential. But is the art that
Greenberg champions really as self-referential as he claims? Is
it flat enough? Literal enough? Superficial enough? Or does
modernist painting harbor depths that Greenberg prefers to
ignore?

Tansey is suspicious of Greenberg's claims. In a delight-
fully pointed painting, *Myth of Depth,* he depicts Jackson
Pollock walking on water while Greenberg lectures Kenneth
Noland, Mark Rothko, Ashile Gorky, Robert Motherwell,
and Helen Frankenthaler, who are all crowded into a tiny
lifeboat.[7] Tansey not only parodies the messianic aspirations
of Greenberg and his followers but also suggests that
Greenberg's position is without foundation. If, after all, figu-
ration can be abstract, why can't abstraction be representa-
tional? While the work of the New York School is evidently
abstract, it is nonetheless representational. No longer referring

The Critique of Judgment. As *l'oeuvre d'art* is self-referential and thus auton-
omous, so the speculative concept is self-reflexive and thus turns back on
itself to form a closed totality. For a more detailed account of Hegel's inter-
pretation of art, see Mark C. Taylor, *Disfiguring: Art, Architecture, Religion*
(Chicago: University of Chicago Press, 1992), esp. chap. 1, "Theoaesthetics,"
pp. 17–47.

7. From 1978 to 1979, Tansey was a studio assistant for Helen Frank-
enthaler.

to things in the world, expressive paintings re-present interior or private experiences in exterior or public figures. The painting, therefore, is not really the thing itself but points beyond itself to the experience it expresses. If artistic progress is marked by suppressing or surpassing representation, then Abstract Expressionism must be left behind.

During the mid-1960s, Minimalism emerged in large measure as a critical response to Abstract Expressionism. From a certain point of view, Minimalists like Donald Judd and Robert Morris seem to break with Greenberg's brand of modernism. By shifting from two- to three-dimensional work, they forsake a preoccupation with opticality. Accepting Greenberg's insistence on the autonomy of different arts while stressing interests that apparently are rather different from those of much modernist painting, Morris admits that the values of painting and sculpture are at odds with each other. Furthermore, the issues addressed in modern painting and sculpture differ significantly. While painting has long been wrestling with the question of representation and the problems it implies, sculpture, by contrast, "never having been involved with illusionism could not possibly have based the efforts of fifty years upon the rather pious, if contradictory, act of giving up this illusionism and approaching the object."[8] However, intentions to the contrary notwithstanding, the perspective of Morris and his fellow Minimalists turns out to be closer to Greenberg's position than they realize. Without underestimating their noteworthy disagreements, it is still possible to understand Minimalism as consistent with the very tendencies and values Greenberg identifies. Minimalism promotes a literalism that extends the self-referentiality of the painted surface to the object as such.

In contrast to Abstract Expressionists' concern with interior private experience, Minimalists seem to take Walter Benjamin's analysis of the work of art in the age of mechanical reproduction as prescriptive rather than descriptive. The effort to escape the regime of representation takes two forms

8. Robert Morris, quoted in Charles Harrison, *Essays on Art and Language* (Oxford: Basil Blackwell, 1991), p. 39.

in Minimalism: the depersonalization of production and the literalization of the object. To overcome the privileging of interior experience, which characterizes Abstract Expressionism as well as much European art and aesthetics, Minimalists shift the site of production from the privacy of the studio to public spaces ranging from galleries and factories to plazas and parks. In opposition to the unique creations of artistic genius, they use industrial methods to produce ostensibly standardized works. As hand gives way to machine, the work of art not only takes place in public but is a depersonalized process resulting in objects bereft of aura. Works designed with geometric precision and produced in uniform shapes and industrialized finishes look like they just rolled off the assembly line.

There is an undeniable literalness or facticity about the works of artists like Donald Judd, Robert Morris, and Carl Andre. Judd, for example, reduces the complexity of the art object until the part becomes whole and the whole is without parts. Thus, in Minimalist sculpture, the interest lies more in the object as a whole than in the intricate relationship among the parts. By removing complexity and minimizing ambiguity, Minimalist objects are crafted to establish their literal presence. Such works are supposed to represent nothing other than themselves; they are, in other words, self-referential. The presence of the object is intended to be grasped as a whole or all at once rather than part by part or over time. When understood in this way, the Minimalist object and its apprehension repeat Plato's ascent by inverting its course. While Platonic philosophy is directed to an ecstatic moment in which time gives way to eternity, Minimalism extends the dream of immediacy by effectively collapsing eternity into the time of an eternal now, which seems to exclude past and future.

Our consideration of Hegel's translation of Plato's movement from darkness to light into a visionary philosophy of history suggests further implications of the Minimalists' agenda. Having emerged in large part as a critique of Abstract Expressionism, Minimalism, in turn, harbors further artistic developments. Through something like a dialectical reversal, the literalism of Minimalism gives way to the idealism of Con-

ceptual Art. In good Hegelian fashion, Minimalism bears the seeds of its own negation. As the work of art is simplified by being reduced to a minimum, the locus of relationships and the complexity they entail shifts from the object to the subject. Commenting on Minimalism in 1966, Morris claims that "the better new work takes the relationships out of the work and makes them a function of space, light, and the viewer's field of vision."[9] While Morris is more concerned with perception than conception, the shift from object to subject that he notes is crucial for the emergence of Conceptualism.

Many factors, of course, contributed to the development of Conceptual Art. In an effort to resist the growing commodification of art, some artists attempted to make art that could not be bought and sold like consumer products or traded like commodities, currencies, and financial securities. Movements as different as Earth Art and Performance Art share profound misgivings about the gallery system and all it represents. By producing art that cannot be shown in galleries, or whose impermanence renders its sale problematic, artists attempted to subvert the art market. Conceptualism, which also emerged in the 1960s, attempts to resist the commodification of art by extending the process of abstraction to the point of dematerialization. When the object disappears, there would seem to be nothing left to sell.[10]

It is important to stress that Conceptual Art includes a range of diverse artistic practices unified in an identification of the work of art with concepts or ideas rather than material objects. While many critics trace the roots of Conceptualism back to the "antiretinal" proclivities of Marcel Duchamp, it is more helpful in this context to understand this development as the concluding chapter in the critique of representation developed in postwar art. In Conceptualism, not only represen-

9. Ibid., p. 44.
10. Market forces, of course, are remarkably resilient and have the capacity to incorporate even what is designed to resist them. Accordingly, it was not long before videos of performances were being sold and expensive trips to distant Earthworks were being arranged by art galleries. In the absence of material works of art, some artists went so far as to market their ideas by selling written texts.

tations but the object itself disappears. In what has become a canonical text, "Paragraphs on Conceptual Art," Sol LeWitt formulates the fundamental tenet of this artistic tendency: "Ideas alone can be works of art; they are in a chain of development that may eventually find some form. All ideas need not be made physical."[11] This insistence that works of art can become ideas and that ideas can be works of art recalls Hegel's interpretation of the end of art. In this case, the eclipse of representation by concept no longer involves the shift from art to philosophy but now takes place within art itself. When the work of art becomes a concept or idea, art would seem to have become, as Hegel declared, "a thing of the past."[12] Like a cowboy shooting his own image in the mirror, visual art appears to die by its own hand. Whether or not Conceptualism is the end of art, it surely seems to be the end of painting.

As I have noted, however, even though the cowboy and his image are shot full of holes, they both remain standing. Painting, it seems, is more resilient than its critics admit. Contrary to expectation, the disappearance of representation and the dematerialization of the work of art prepare the way for the return of painting through something approaching an identification of art and writing. As ideas displace images, the "essence" of the work of art is, in many cases, recorded in written texts, which can, for example, provide a documentary record of a performance or set of instructions for the fabrication of an object. In such cases, the work of art is not simply the idea but written *information.*

This transformation of the work of art into information has three important consequences. First, when the artwork is an idea recorded as information, the line supposedly separating theory from practice, and, by extension, differentiating criticism from art, becomes hopelessly obscure. This conclu-

11. Sol LeWitt, quoted in Harrison, *Essays on Art and Language,* p. 47.
12. Hegel is not suggesting that art is over but that its historical mission of revealing truth to evolving self-consciousness passes first to religion and then to philosophy. Nor do conceptualists deny the persistence of various strategies of representation. Their point is that art can no longer advance if it is not conceptual.

14

sion is implicit in Greenberg's appropriation of Kant's critical philosophy to define modernist painting. Greenberg's position actually makes painting or any artistic practice indistinguishable from art criticism. When art uses "the characteristic methods of a discipline to criticize the discipline," artistic practice is, in effect, critical theory. As we shall see below, the converse is also true: critical theory becomes, in some sense, artistic practice. Second, Greenberg's effort to establish the autonomy of different arts eventually negates itself by creating the conditions for a unification of the visual and the verbal. As image becomes idea, which is recorded in information inscribed as words, information and words become the material for the creation of images. This leads to a third and final consequence of Conceptual Art. Since information is not only recorded in words but is often stored in images, the transformation of the work of art into information can lead to a return of images. While not necessarily referring to things in the world, these images nonetheless might be referential. Paradoxically, Conceptual Art both marks the conclusion of the disappearance of representative images and creates the conditions for the return of hyperrealistic images. Though seemingly opposite, Conceptualism actually prepares the way for the processing of information in the images of Photo-Realism.

The McLuhanesque world of the late twentieth century makes the informational value of images increasingly evident. When "the medium is the message," images not only shape perception but also communicate information and convey ideas. In an age of electronic reproduction, artists, not surprisingly, were among the first to appreciate the importance of data stored in images. "In the narrower domain of art," Robert Hughes observes, "the vogue for 'information' went two ways in the early seventies. One took the form of conceptual art; the other, a direct descendant of Pop Art, was Photo-Realism. No art ever celebrated the random sight with such enthusiasm: these literal snapshots of store windows, suburban shopping malls, motorcycles, aircraft engines, or rodeo horses, enlarged and then rendered in fulsome detail with an air-brush, derived much of their popularity from the sheer

accumulation of data in them."[13] Though the style seems transparent, the genealogy of Photo-Realism is quite complex. Modern Realism can be traced to Gustave Courbet who, in 1861, recorded a stunningly prescient observation: "painting is an essentially *concrete* art and can only consist in the presentation of *real and existing things*. It is a completely physical language, the words of which consist of all visible objects; an object which is *abstract,* not visible, non-existent, is not within the realm of painting."[14] In order to apprehend things as they are, the Realist painter attempts to develop a "styleless style." As Linda Nochlin explains, "early realists were stressing the importance of confronting reality afresh, of consciously stripping their minds, and their brushes, of secondhand knowledge and ready-made formulae."[15] From one point of view, Realism's cultivation of what Tansey ironically labels "the innocent eye" is an effort to emulate scientific objectivity, which is supposed to deal with nothing but facts (see *The Innocent Eye Test*). In addition to the innocence of the eye, the pursuit of facts, promoted by nineteenth-century Realists, also presupposes sincerity and honesty. Deception and trickery, therefore, were prohibited in the artistic practice of Realists.

By the time Realism returns a century later, both the facts observed and the eye observing them have changed considerably. In the wake of Einstein's theory of relativity and Heisenberg's uncertainty principle, facts no longer seem to be quite so objective. Moreover, the "hermeneutics of suspicion" developed by Marx, Freud, and Nietzsche and elaborated by their followers exposes the eye as not-quite-so-innocent. While the confounding of facts and relativizing of knowledge resulting from these developments in "high" culture are of decisive importance for twentieth-century art, changes in popular culture during the 1960s and 1970s are no less significant. The spread of the media and the dawn of the information age combine first to transform both things into images and

13. Robert Hughes, *The Shock of the New* (New York: Knopf, 1980), pp. 364–66.

14. Linda Nochlin, *Realism* (New York: Penguin Books, 1971), p. 20.

15. Ibid.

images into things, and then to reveal the "substance" of "reality" to be coded information. Photo-Realism cannot be adequately understood apart from these broader cultural developments.

Not all the New Realists, however, were Photo-Realists; many started their careers as abstract painters. Figuration, I have noted, can be abstract when it is rendered formally. Commenting on painters like Philip Pearlstein, Lennart Anderson, Jack Beal, and Alex Katz, Nochlin explains:

> Yet if one rejects the narrow, abstractionist aesthetic teleology as the proper framework for viewing New Realism, one must by no means ignore the central role played by recent abstract painting itself in the formulation of the New Realist style. The largeness of scale, the constant awareness of the fieldlike flatness of the pictorial surface, the concern with measurement, space, and interval, the cool, urban tone, with its affirmation of the picture qua picture as a literal fact, the rejection of expressive brushwork, or, if it exists, the tendency toward bracketing its evocative implications through irony or overemphasis—all of these elements bring the work of the New Realists closer to the spirit of contemporary abstraction and serve to dissociate it irrevocably from the meretricious mini-platitudes of a self-styled "old" realist—like Andrew Wyeth.[16]

Resisting the temptations posed by mimesis and accepting the flatness of the picture plane, these Realists deploy the fundamental tenets of Greenberg's reading of modernist painting in the interests of figuration rather than its negation.

The similarities between New Realism and the so-called New Novel, which was emerging in France at about the same time, have often been noted. Explaining his method, Alain

16. Linda Nochlin, "Realism Now," in *Super Realism: A Critical Anthology,* ed. Gregory Battcock (New York: E. P. Dutton, 1975), pp. 115–16. The remarkable work of Chuck Close offers an even more graphic illustration of Nochlin's point. By refiguring grids as pixels, Close depicts the transition from the mechanical to the digital.

Robbe-Grillet, the leading practitioner of the New Novel, writes:

> To describe things, as a matter of fact, is deliberately to place oneself outside them, confronting them. It is no longer a matter of appropriating them to oneself, of projecting anything onto them. Posited, from the start, as *not being man* they remain constantly out of reach and are, ultimately, neither comprehended in a natural alliance nor recovered by suffering. To limit oneself to description is obviously to reject all other modes of approaching the object.[17]

In his 1981 painting entitled *Robbe-Grillet Cleansing Every Object in Sight,* Tansey pictures the writer scrubbing miniature figures and fragments as he kneels in a desert littered with ruins. Twelve years later, Robbe-Grillet responds to Tansey's painting in the introductory essay for a catalog accompanying an exhibition of his work. Concluding "A Graveyard of Identities and Uniforms," Robbe-Grillet writes:

> All around, the deathly aspect of the setting seems even more disturbing to the belated cavalryman's overwrought nerves: this unknown town, built in ebony, basalt, obsidian, and Astrakhan marble, which figures on no known map, was it no more than a monumental graveyard, sheltered by mistake? In the foreground, toward the right-hand corner of the frame, a large upright stone, carved in roman capitals, still exhibits the name of a builder of mausoleums and cenotaphs: Mark Tansey, Architect.[18]

In Tansey's picture of Robbe-Grillet, the writer becomes a painter as pen is replaced with brush. Just as Robbe-Grillet attempts to create a prose that erases itself so as to render things perfectly transparent and totally present, New Realist painters try to devise a styleless style of pictorial representation

17. Alain Robbe-Grillet, *For a New Novel: Essays on Fiction* (New York: Books for Libraries, 1965), p. 45.

18. Alain Robbe-Grillet, "A Graveyard of Identities and Uniforms," in *Mark Tansey,* ed. Judi Freeman (San Francisco: Chronicle Books, 1993), p. 11. Hereafter references to this work are give in the text as MT.

that effectively overcomes representation. Tansey is convinced that this strategy is a dead end.

The implicit and explicit influence of the New Novel on New Realism should not overshadow another important development unfolding in France at the same time that also influenced artistic practice. In 1961, Maurice Merleau-Ponty published *Phenomenology of Perception*. This seminal work brings to fruition insights initially formulated in the analyses of painting and the novel presented in *Sense and Non-Sense* (1948) and anticipates important ideas advanced in his posthumous *The Visible and the Invisible* (1964).[19] Though tracing its roots back to Platonic idealism, modern phenomenology grows out of Hegel's *Phenomenology of Spirit* (1807). In the early decades of the twentieth century, Edmund Husserl and his student, Martin Heidegger, elaborated central aspects of Hegel's analysis to form a distinctive philosophical position. As the term implies, phenomenology takes as its task the study of the *logos* or logic of phenomena. In its earliest version, phenomenology is thoroughly idealist. Rather than empirical objects or material entities, the phenomena phenomenology describes are ideal structures. Appropriating Plato's doctrine of the forms, Husserl identifies the essence of the object as its *eidos,* or idea. By "bracketing" preconceived notions and suspending prejudices, the eye, Husserl argues, can become sufficiently innocent to apprehend the essence of things *directly and immediately.* The rallying cry of phenomenology became *"Zu den Sachen"*—"to the things themselves!" Though sharing Husserl's preoccupation with things as such, Merleau-Ponty is persuaded that perception is more primordial than conception. Thus, in *Phenomenology of Perception,* he attempts

19. Merleau-Ponty's *Phenomenology of Perception* exercised a strong influence on Minimalism. Robert Morris was particularly intrigued by Merleau-Ponty's argument and used his analysis of perception as a guide in creating his art. Rosalind Krauss, who, as I have noted, along with Morris was one of Tansey's teachers at Hunter College, was also a devoted student of Merleau-Ponty. In some of her early writings, Krauss approaches Minimalist sculpture through Merleau-Ponty's phenomenology. See, e.g., Rosalind Krauss, *Passages in Modern Sculpture* (Cambridge, MA: MIT Press, 1977).

to shed every vestige of idealism by demonstrating the primacy of perception. The immediate contact between subject and object, which is the aim of phenomenological inquiry, Merleau-Ponty insists, can only be attained through pre-reflective perceptual experience.

As the appeal to turn to things themselves becomes more urgent, the precise nature of the thing becomes less obvious. In one of his most provocative essays, entitled simply "The Thing," Heidegger poses questions to which he realizes there are no clear answers: "What in the thing is thingly? What is the thing in itself?"[20] The longer such questions are pondered, the more puzzles proliferate. Is a thing material or immaterial? Real or ideal? Factual or imaginary? What if a thing is not a thing but is an image? What if a thing is actually (coded) information?

By the 1960s, such questions were not merely philosophical. The spread of electronic technology and media culture was quickly making thing and image virtually indistinguishable. In a world increasingly driven by advertising and governed by televisual technologies and computer networks, things become images and images become real. Reality, in other words, becomes a matter (or nonmatter) of image. Pop artists had, of course, recognized this important development and anticipated its far-reaching significance. From Robert Rauschenberg's combines and Jasper Johns's flags and targets to Andy Warhol's soup cans and celebrity silk screens, postwar media and consumer culture become the insubstantial substance of the work of art. If the thing itself is an image, then the return "to the thing itself" involves nothing more and nothing less than a turn to the image as such.

Paradoxically, the very instrument that was, in large measure, responsible for the demise of Realism in the nineteenth century led to its revival in the twentieth century. With the advent of photography, the urgency of the Realist imperative in painting diminished. If photographs record things and events clearly and accurately, what reason is there for painting

20. Martin Heidegger, *Poetry, Language, Thought,* trans. Albert Hofstadter (New York: Harper and Row, 1971), p. 167.

to try to do the same thing less adequately? By the middle of the twentieth century, not only had photography become an art but the eye of the camera was acknowledged to be no more innocent than the human eye. When painters like Richard Estes, Ralph Goings, Tom Blackwell, and Steven Posen turn to photographs for their subject matter, they extend appropriative strategies at work in Pop Art's use of images drawn from the worlds of commercial and popular culture. Both Pop artists and Photo-Realists paint signs of signs and images of images. In this infinite interplay of signs and images, realism becomes a hyperrealism that further confounds the problem of representation. The paintings of the Photo-Realists appear to be representative because they seem to point "beyond" themselves to something they re-present. And yet, what they re-present is not an object or thing but another image, or, more precisely, a thing that is an image. When the sign is a sign of a sign, the image an image of an image, and the representation a representation of representation, ostensible reference is actually self-reference. Though obviously different from abstract canvases, seamless objects, and immaterial ideas, the works of Photo-Realists remain self-referential. Abstract Expressionism, Minimalism, Conceptualism, and Photo-Realism reach similar conclusions from alternative directions. On the one hand, representations are stripped away to expose the thing itself and, on the other hand, the thing is collapsed into representations, which refer to nothing beyond themselves. In the final analysis, both of these strategies are designed to overcome the mediation inherent in representation. In the flatness of the canvas, the wholeness of the sculptural object, the purity of the idea, and the literalism of the image, the ancient dream of immediacy lives on. As Plato long ago realized, what makes the search for immediacy so persistent is the seemingly irrepressible longing to escape or stop time.

2 Re-presenting Representation

While the major currents circulating in the art world during Tansey's formative years differ significantly, they share what he regards as an oversimplified view of representation. From Plato and Hegel to the artistic tendencies dominant in the 1960s and 1970s, representation appears to be a problem that must be overcome. Approaches to producing art that share little else seem united in their effort to attain immediacy by negating the medium.[1] The medium seems to be something like a screen, boundary, or limit separating subject from object and thereby impeding their perfect union. Tansey, by contrast, argues that the experience of immediacy is impossible and the limit of the medium is unavoidable. Furthermore, the dream of immediacy is both artistically unproductive and socially and politically undesirable. Instead of engaging in a fruitless struggle to negate mediation, Tansey maintains, painters should probe the possibilities and limitations of their medium. Painting, he insists, is inescapably rhetorical. Far from representing reality, pictures probe multiple realities by fabricating narratives of events that never occurred. Instead

1. In opposition to this claim, the insistence that art is about art, it might be argued, implies that art is about nothing but its distinctive medium. However, when we understand both the form and content of art through the notion of self-reflexivity, it is clear that the purpose of self-critical art that issues in transparently flat surfaces that point to nothing beyond themselves is to negate structures and processes of mediation.

of attempting to erase the medium to get to the thing itself, Tansey insists that the medium is the message and the message of the medium is that there is no escaping representation. Accordingly, the task of painting at "the end of painting" is to paint what painting has left unpainted by soliciting the return of the repressed through a ceaseless questioning representation.

This is not to recast representation as though it were again in exile. It's not as though art discourse is moving away from representation, or that textual criticality is situated hierarchically against or outside it. They were also forms of representation. What we have is a dialogue where the critique of one representation is by another. Art discourse is a clash of representations.[2]

Though not initially apparent, this clash of representations revolves around the problem of time and, by extension, history.

To experience immediacy would be to enjoy a presence uninterrupted by absence in a present undisturbed by memory of the past or anticipation of the future. Such a moment would be totally present here and now. Representation negates this moment of immediacy, or, more accurately, discloses that it has always already been negated by showing that presence is never totally present and the present is never simply presence. As a structure of substitution, representation involves an irrepressible interplay of presence and absence. A representation is never the thing itself but always something else or something other. Conversely, the thing itself is never a representation but always something else or something other than what it appears to be. Since absence inevitably haunts representation, representations figure a lack that cannot be filled. Far from rendering presence present, representation is, in effect, a de-presentation. Herein lies the duplicity of the prefix that fixes nothing: re-. In the medium of

2. Arthur Danto, *Mark Tansey: Visions and Revisions,* ed. Christopher Sweet (New York: Harry Abrams, 1992), p. 135. Hereafter references to this work are given in the text as VR.

painting, the picture is the absence—perhaps even the death—of the thing.

If representation figures an absence approaching death, the struggle against representation is an indirect effort to negate death. In order to master death, it would be necessary to conquer time by making both presence and the present last. When time no longer passes, the here and now is eternal. In the 1960s and 1970s, as we have seen, artists deployed two strategies to surmount representation: they either strip away representations, leaving nothing but the thing itself, or they fashion the thing into a representation, thereby transforming what had been the representation of something else into the thing itself. These alternative tactics share a certain literalism: neither object (whether abstract canvas or minimal sculpture) nor image (whether Pop or Photo-Realist) means or points to anything beyond itself. An aphorism popular at the time captures the point: "What you see is what you see." The literalism of the object is mirrored in the immediacy of the experience through which it is apprehended. The work of art is intended to be enjoyed in a here-and-now that entails neither past nor future.

From the beginning of his career as an artist, Tansey realizes that the modernist attack on representation grows out of what he aptly describes as a "temporal chauvinism that absolutizes the narrow present" (VR 135):

> The word Postmodern in its most obvious sense is a temporal designation. If Postmodern practice is attempting to break from Modernism, why hasn't the notion of the narrow present been questioned? Is there a temporal chauvinism here that makes it possible for art discourse to ignore all other structures of time (cultural, biological, geological, physiological, cosmological, etc.)? If one can get beyond the prohibitionary reflex action, it might be possible to look more closely at the content of representational or other modes of art to see the degree to which they are sensitive and accountable to other structures of time. (VR 135)

Tansey attempts to develop strategies and tactics that will allow him to expand this narrow present beyond the limits

set by modernism. This shift in the temporality of the work of art is impossible without a break with or subversion of modernist painting. The very word "modern," after all, derives from the old French *moderne,* which originates from the late Latin *modernus* and *modo,* meaning "just now." Thus, the modern is current, up-to-date, here and now, of the moment. To be modern is to be unburdened by the past. Since the past is always out-of-date, it must be either forgotten, repressed, or destroyed. Describing what he calls "the tingle" of modernity, Warhol writes: "I have no memory. Every day is a new day because I don't remember the day before. Every minute is like the first minute of my life."[3] As Warhol's ironic comment implies, the affirmation of the present by way of the negation of the past testifies to modernism's unfailing commitment to originality. When every minute is the first minute, the past is left behind and originality seems possible. If modernism has one imperative, it is: Make it new! When the highest value is originality, the present is what really matters.

While modern philosophy, as Jacques Derrida argues, presupposes a "metaphysics of presence," modern art, which struggles against representation and for immediacy, involves what might be described as an "aesthetics of presence." The issue on which Tansey's critique of modernism turns is the interplay of temporality and representation. By reconceiving representation, Tansey is actually rethinking modernism. As we shall see in more detail in what follows, the problem of representation is inseparable from the question of time. In all his art, Tansey asks: Can the density and complexity of temporality be figured in painting? Realizing the futility of trying to break with the past, he turns modernism against itself in an effort to demonstrate its impossibility. As if following Greenberg's definition of modernism as "the use of characteristic methods of a discipline to criticize the discipline itself," Tansey interrogates representation in and through representations. He does not simply reject the artistic tactics that were dominant at the time he began painting but extends

3. Andy Warhol, *The Philosophy of Andy Warhol* (New York: Harcourt Brace, 1975), p. 199.

the strategy of appropriation from content to method by borrowing the techniques of others to forge his distinctive style. To the tutored eye, traces of Abstract Expressionism, Minimalism, Conceptual Art, and Photo-Realism are evident in Tansey's intricate compositions. Since he refuses to accept the principle of autonomy in method as well as content, Tansey remains free to mix concepts, figures, forms, and colors as if they were colors.

As we have seen, Tansey, taking nothing for granted, questions the very possibility of painting. *Where* and *how* does one begin to paint after the end of painting? Perhaps, he concludes, the point of departure remains what it has always been: the blank canvas. In a certain sense, painting reaches closure with the ostensibly blank canvas of abstraction. The end of the evolution of modernist painting, as charted by Greenberg, is an "empty" canvas from which representation seems to be absent. But, as always, appearances are deceptive. The blank canvas is not really blank; nor is it strictly nonrepresentational. To the contrary, the monochromatic canvas is a formless form that is supposed to represent (without representations) an immediate experience, one that marks the end (i.e., the aim and conclusion) of painting.

All of Tansey's paintings start with what appears to be a blank canvas.[4] He begins by painting the entire canvas white and then proceeds to double the "emptiness" of abstraction by superimposing a colored monochromatic surface on a white monochromatic base. This method both revives the popular nineteenth-century practice of layering by underpainting and recalls the creation of the image on the photographic negative by the removal of silver nitrate. Having established a foundation that is undeniably duplicitous, Tansey does not form figures by adding them to a blank background but proceeds by subtraction. This method deliberately reverses the trajectory Greenberg plots. Whereas Greenberg argues that the advance of modernist painting involves the progressive disappearance of figure in ground until the undifferentiated surface becomes

4. Conversations with my colleague Ed Epping have helped to clarify my understanding of Tansey's technique for producing pictures.

the thing itself, in Tansey's pictures, figures emerge from a figureless ground through a process of subtraction that differentiates the undifferentiated surface. Confounding opposites usually held apart, this technique involves a subtraction, which, paradoxically, is an addition.

By creating through a process of erasure, Tansey discloses the inseparability of representation and temporality. Since representation is impossible apart from something like an "originary" loss, the presence of every representative figure presupposes a certain absence. That which is already missing constitutes something like an irreducible past—a past that was itself never present and thus cannot be re-presented. And yet, this past is at the same time the condition of the possibility of all presence and every present. The present emerges from that which has always already withdrawn and is, therefore, forever haunted by an absence that cannot be overcome. For this reason, the present always represents something that cannot be re-presented. The present, in other words, inevitably points beyond itself to a radical past, and thus the presence of every form or figure necessarily refers to an irreducible absence. If the present can never be fully present, the longing for immediacy is an idle, perhaps even destructive, dream. Moreover, both the purported literalness or facticity and the self-referentiality of the object collapse into a void that cannot be filled.

In *Action Painting* and *Action Painting II,* Tansey explores the contradictions involved in the effort to capture the immediacy of experience in paintings that are supposed to refer to nothing beyond themselves. In the first work, a woman is painting a picture of an exploding car. As she raises a pencil to measure perspective, her canvas displays an accurate representation of the car, which seems to have appeared there instantaneously. In the second painting, a group of young and old artists have set up their easels on the shore of Cape Canaveral and are working on pictures of the spacecraft Challenger as it lifts off. Though a clock indicates that only eight seconds have passed since ignition, every artist has already completed a perfect picture of the launch. By superimposing different modalities of time, Tansey indicates the complexity of tempo-

rality and the multiplicity of the present. Temporal rhythms are not uniform but vary from context to context. Moreover, the *nunc stans* never stands still but has always already vanished. Since time can be apprehended only as it slips away, there is always a delay between experience and its representation. The space of this deferral is the medium of the painter.

Tansey explores this timely space by both *what* he represents and *how* he represents it. In contrast to action painters who claim that originality can be achieved by the spontaneity of gesture, Tansey deliberately incorporates time and temporal delay in his painting strategy. After blocking out the canvas, he covers a section of it with liquid paint and proceeds to create figures by gradually removing paint. As the surface dries, different forms and effects can be created by gestures ranging from delicate accenting to abrasive scraping. After several hours, it becomes impossible to refine or change the images. With this carefully devised technique, Tansey turns time into a creative medium for the creative process. Instead of trying to capture the fleeting moment in a spontaneous gesture, he turns the seemingly destructive tendencies of time to creative ends. Paint, like life itself, moves from wetness, fluidity, and flexibility to dryness, stiffness, and rigidity. Creative activity has to work with the entropic propensity of time. One must, in other words, learn to figure while the paint is drying.

Tansey's method of layering and use of time to produce figural gradations result in canvases that are richly textured rather than simply flat. Layering creates deep, even profound surfaces. When Tansey peels away the surface, he does not discover the thing itself but uncovers another surface. In and through this play of surfaces, forms and figures gradually emerge. The images he calls forth are strikingly realistic. Indeed, they border on a hyperreality approximating the best works of the Photo-Realists. This resemblance is not accidental; Tansey deliberately evokes images reminiscent of Pop Art and Photo-Realism. The representations he paints are not original but are copies of copies, images of images, and pictures of pictures. Unlike Pop artists and Photo-Realists, however, Tansey does not attempt to erase his medium by making

it perfectly transparent or completely self-referential. To the contrary, by picturing pictures, he exposes the medium and shows the inescapability of mediation.

The incorporation of found images into the work of art has become commonplace for many recent artists. From David Salle's meticulous paintings and Cindy Sherman's uncanny photographs to Duane Hanson's and Jeff Koons's kitsch sculptures, images borrowed from popular magazines, books, films, and media form the substance of so-called high art.[5] Over the years, Tansey has accumulated an enormous image file that he uses to create his paintings. This collection of images serves as an "artist's notebook" in which he explores different themes and outlines preliminary studies. In preparation for every painting, Tansey develops a series of detailed sketches. Instead of working directly from appropriated images, he uses xerox copies to create collages, which eventually become the basis of the finished painting. This use of mechanical reproduction is reminiscent of the depersonalized methods of industrial production favored by the Minimalists. But unlike Minimalists, Tansey deliberately mixes handwork and mechanical reproduction. The photocopy machine he uses can be interrupted to allow him to modify the dust from which the copy is formed before the image is fixed. By carefully sifting and shifting particles of dust, he retouches the image. After reworked pictures are copied, they are further transformed by cutting and recombining them. These altered figures are then reproduced yet again by the handwork of painting. Through this long and involved process, the line between the personal and impersonal, original and copy, and mechanical and handmade is completely obscured.

While Tansey's use of photocopies follows the practices of Photo-Realists, his preference for monochrome rather than "technicolor" is a distinctive characteristic of his art. Richard

5. For a discussion of the relevance of Salle's work for this issue, see Mark C. Taylor, *Nots* (Chicago: University of Chicago Press, 1993), pp. 166–211. I consider related aspects of Sherman's art in chap. 5 of *Hiding* (Chicago: University of Chicago Press, 1997).

G. Tansey comments on this aspect of his son's work in his revision of Helen Gardner's *Art through the Ages:*

> Drawing fully on the resources of photography, especially as it is found in newspapers and magazines, Mark Tansey makes oil paintings that comment wryly and wittily on the contemporary world. His method is to bring persons, things, times, places, and events that are not usually—if ever—associated into new and surprising conjunctions and to render them in fully pictorial tonalities reminiscent of on-the-spot news photography. He prefers monochromatic sepias and gray-greens, recalling the color of old rotogravure pictures printed decades ago in Sunday newspaper supplements.[6]

Tansey's paintings often seem less fashionable than oddly out-of-date—as if they belong to an era long past. While the modern abstractionists against whom he is reacting use monochrome to create a sense of immediacy and self-referential presence, Tansey sees in monochrome a further resource for insinuating a different sense of temporality into painting. By suggesting aged photographs and magazine clippings, Tansey opens the present to evocative memories from the past. The passing of time haunts his images. Even when their colors are bright, a certain patina clings to Tansey's paintings. The colors he selects for his monochromes are unusual; his palette is for the most part limited to distinctive shades of blue green and red orange. In a few paintings he also uses yellow, brown, and a deep reddish purple. These colors, according to Tansey, suggest a scale ranging from cool (blue green) to warm (red orange). While yellows and browns fall toward the warm end of this spectrum, reddish purple, which is made by mixing red and blue, is simultaneously warm and cool. This calculated use of color in pictures that appear outdated has the

6. Richard A. Tansey, *Gardner's Art through the Ages* (New York: Harcourt Brace Jovanovich, 1986), p. 958. Arthur Danto also stresses this aspect of Tansey's work: "The paintings are monochrome and seem themselves to be dated and somewhat old-fashioned, resembling plates of rotogravure of the kind I remember looking at in heavy volumes at my grandparents' house" (VR 12).

effect of creating a jarring juxtaposition between the past and present. Old pictures seem to have received a bright new wash and yet remain uncannily aged. By mixing times as well as colors, Tansey further complicates the question of temporality. His effort to extend the boundaries of time beyond the narrow present does not, however, end with the use of appropriated images and distinctive coloration.

Tansey further underscores the significance of his expanded notion of temporality when he points to an important relation between the texture of his paintings and textiles, texts, and traces. This series of associations plays on the etymology of the word "text," which derives from the Latin *textus* (woven thing), the past participle of *textere* (to weave). Since texts are created by weaving, they constitute something like textiles. When paintings are not flat but complex textures, they can, like all texts, be read in many ways. Tansey draws this insight from the arguments about textuality developed by philosophers and literary critics. Texts, he concludes, are representations and, conversely, representations are texts. This interplay between textuality and representation creates a multiplicity of meanings that is a rich resource for the artist. This insight leads Tansey to conclude that the interpretation of layered textures shatters the immediacy of optical sensation by insinuating the past into the present moment of perception. Since opticality is limited to the immediacy of the narrow present, it cannot be read. Reading presupposes a process of mediation through which the present assumes coherence by its relation to the past and future. For example, the meaning of any word depends on its relation to the words that come before and after it. Since reading is a temporal activity, if paintings are to be read, they must be inherently temporal.

Tansey's claim that it is possible to read painted surfaces stands in direct contradiction to the purported autonomy of different arts. Greenberg not only separates the three-dimensionality of sculpture from the two-dimensionality of painting but also attempts to exclude narrativity and textuality from the visual arts. If the purity of *l'oeuvre d'art* is to be preserved, word and image cannot mingle. However, contrary to expectation, the proscription of writing leads to its

proliferation. While Greenberg's theory rigorously excludes writing from visual works, Pop artists and Photo-Realists insist on including words on the surface of their paintings. Even when apparently absent, the written word is not far away. Minimalists, as I have noted, are relentlessly theoretical and frequently supplement their art with written texts. Eventually, Conceptualists transform the written text itself into a work of art.

Tansey realizes the far-reaching implications of the artistic and literary discussions about the status of writing. During the late 1970s and early 1980s, he began reading Derrida's works and following the debates they provoked. In a later chapter, I will consider the impact of Derrida's writings on the questions Tansey probes in his paintings. In this context, it is sufficient to note that Tansey literally uses Derrida's texts to produce paintings. By so doing, he indirectly suggests an important similarity between Derrida's notion of textuality and the appropriative strategies deployed by artists. In opposition to the account of creativity that grows out of the romantic understanding of genius, Derrida insists that no work is original. Writing is always a rewriting of what has already been written. Rejecting the avant-garde imperative to make everything new, Derrida maintains that it is never possible to wipe the slate clean. Beginning is always a beginning again, which occurs in the midst of networks of influence that simultaneously surpass and encompass every individual. The search for originality is nothing more than an alternative version of the dream of immediacy. According to Derrida, experience, thought, and writing are always mediated by inescapable structures of signification. From this point of view, texts are constituted by a play of signifiers, which create and are created by differential networks where meanings arise and pass away. The origin—whether conceived in terms of the subjectivity of the writer/artist or the objectivity of the thing itself—has always already withdrawn from the field of the text. Derrida's works never begin de novo but are always written about— that is, on, around, near—other texts. His writings are densely textured without being deep. Like a Jasper Johns target, Derrida's texts are signs of signs, but unlike painterly

signifiers, they are less concerned with what signs present than with what representations leave out.

In his questioning of representation, Tansey violates the correlative modernist principles of autonomy and purity by incorporating texts in his paintings through a technique made famous by Warhol: silk-screening. The texture of many of Tansey's most effective works is created by a careful layering of silk-screened texts. As text is superimposed on text, figures gradually emerge. When images are formed from texts, it becomes apparent that there is a graphic dimension to all writing; writing is figurative even when it seems to be direct. Furthermore, painting is graphic even when writing is not visible. Tansey's tactic of appropriating texts in his paintings results in a structure of substitution that suggests a regression without origin or end. Textual figures are always representations of something that cannot be presented or re-presented as such. Tansey underscores the painterly quality of writing and the writerly dimension of painting by actually erasing the line separating word and image. "It seemed to me," he explains,

that this rather strained dichotomy could be questioned pictorially by putting text into play literally and figuratively. By beginning with the printed page's motif: on one side the text and on the other side the image. The underlying questions were: How does representation transform into text? Where does the pictorial rhetoric begin and where does it end? . . .

Silkscreen working as an extension of the copy machine provided the method of textual reproduction. . . . The objective here was to embed the conceptual conflict between the reproduced and the hand-painted into the work process so that every moment of painting, each granule of paint was oscillating between hand-made and reproduced, between representation and text. . . . The silkscreens were made from collaged texts. I used the copy machine and reprinted and overprinted and did transparent overlays as well as crumpling and abrading in various ways to develop this textual image. So, in a sense, it becomes

a literalizing of Derrida's notion of the text "under erasure" (*sous rature*). (VR 132)

This "literalizing of Derrida's notion of the text" has the effect of deliteralizing the work of art. As texts reinscribe texts, so pictures within pictures figure copies, which are copies of manipulated copies. By establishing a close relationship between figures and texts, Tansey does not create an idealism of the image any more than Derrida promotes a pantextuality that is without remainder. Since representation always de-presents while re-presenting, neither figure nor text is ever complete or exhaustive. The absence haunting representation repeatedly places the picture in question.

Instead of turning away from painting and the questions raised about it, Tansey transforms painting into a questioning. Like Jacques Lacan,[7] Tansey repeatedly seems to ask: "What is a picture?" Picture making, he concludes, is an inquiry or a process of questioning. Every solution he proposes dissolves

7. Jacques Lacan, *The Four Fundamental Concepts of Psycho-Analysis,* trans. Alan Sheridan (New York: Norton, 1978), p. 105. Though Tansey does not engage his writings, Lacan's analysis of the intricate relationship among the imaginary, symbolic, and real is relevant for the issue of representation. What Lacan labels "the real" is never present as such but only "appears" by disappearing. Since something is missing from every representation, signs are not self-referential but are always lacking and thus inevitably point beyond themselves. It is precisely this lack that sets the process of representation in motion and keeps signs in play. The Lacanian "gaze" seeks to close the gap between the signifier and the signified. But this "omniscient" point of view remains imaginary and, therefore, cannot be realized. Commenting on Merleau-Ponty's *Phenomenology of Perception,* Lacan concludes:

> Indeed, there is something whose absence can always be observed in a picture—which is not the case in perception. This is the central field, where the separating power of the eye is exercised to the maximum in vision. In every picture, this central field cannot but be absent, and is replaced by a hole—a reflection, in short, of the pupil behind which is situated the gaze. Consequently, and inasmuch as the picture enters into a relation to desire, the place of a central screen is always marked, which is precisely that by which, in front of the picture, I am elided as subject from the geometrical plane. (P.108)

Seeming to achieve the impossible, the picture pictures absence by figuring a hole that cannot be filled.

as much as it resolves. If, as Greenberg contends, painting has achieved its historical destiny, it is not because all of its possibilities have been exhausted but because its complexity has not been realized.

In the best-known painting from his early period, *A Short History of Modernist Painting,* Tansey summarizes the critical analysis of recent art that forms the background for all of his later work. The painting consists of fifty-two images, provocatively executed in an illustrative style and structured like a grid. The format of the painting recalls a work completed almost a decade earlier. In 1971, while still a student at the Art College of Design in Los Angeles, Tansey painted his version of *The Last Judgment,* which is comprised of thirty-two fragments of Michelangelo's Sistine Chapel altarpiece, copied from a Skira reproduction and arranged in a perfectly symmetrical grid.[8] During the years between *The Last Judgment* and *A Short History of Modernist Painting,* he developed a greater appreciation for the significance and complexity of the grid. Rosalind Krauss's important essay "Grids," published while Tansey was working on *A Short History,* presents an insightful and influential analysis of the importance of the grid in modern art. Krauss argues that there are

> two ways in which the grid functions to declare the modernity of modern art. One is spatial; the other is temporal. In the spatial sense, the grid states the autonomy of the realm of art. Flattened, geometricized, ordered, it is antinatural, antimimetic, antireal. . . . In the overall regularity of its organization, it is the result not of imitation, but of aesthetic decree. Insofar as its order is that of pure relationship, the

8. Sixteen years later Tansey returns to Michelangelo's *The Last Judgment* and includes it in *Triumph over Mastery II* in which a painter, suspended with roller in hand on a ladder that has no visible support, spreads a coat of white paint over what appears to be the Sistine Chapel. Tansey's judgment about this pyrrhic triumph is as obvious as the missing shadow the house painter has erased. The project of modernist painting is as unsupportable as a ladder suspended in air so thin that it cannot even cast a shadow. More recently, in *Judging* (1997), Tansey appropriates *The Last Judgment* in an anamorphic image that would have fascinated Lacan.

grid is a way of abrogating the claims of natural objects to have an order particular to themselves; the relationships in the aesthetic field are shown by the grid to be in a world apart and, with respect to natural objects, to be both prior and final. The grid declares the space of art to be at once autonomous and autotelic.

In the temporal dimension, the grid is an emblem of modernity by being just that: the form that is ubiquitous in the art of *our* century, while appearing nowhere, nowhere at all, in the art of the last one. In the great chain of reactions by which modernism was born out of the efforts of the nineteenth century, one final shift resulted in breaking the chain. By "discovering" the grid, cubism, de Stijl, Mondrian, Malevich . . . landed in a place that was out of reach of everything that went before. Which is to say, they landed in the present and everything else was declared to be the past.[9]

The space the grid delineates always involves presence and the time it marks is invariably present. Like ancient Platonic forms, the grid negates temporality by inscribing it within a structure that does not change. "One of the most modernist things" about the grid, Krauss concludes, "is its capacity to serve as a paradigm or model for the antidevelopmental, the antinarrative, the antihistorical."[10]

For Tansey, the work begins as always with the title: *A Short History of Modernist Painting.* If modernism affirms itself by negating the past, how can it have a history? Conversely, if it has a history, can it be modernist? Tansey's deployment of the grid is subversive; by using the grid to plot the history of modernist art, he turns this antidevelopmental, antinarrative, antihistorical device against itself in a way that creates space for time. The squares of the grid suggest a game board like the one that appears several years later in *Chess Game* in which

9. Rosalind Krauss, "Grids," *The Originality of the Avant-Garde and Other Modernist Myths* (Cambridge, MA: MIT Press, 1986), pp. 9–10.
10. Ibid., p. 22.

two soldiers of the avant-garde play while Marcel Duchamp and Alfred Jarry watch. Within the gridded space of the game, time is limited. Only so many moves can be made and when all possibilities have been exhausted, the paint dries and the game is over. But, of course, Tansey's painting is not really a chess board because it has fifty-two rather than sixty-four squares. Far from arbitrary, this number suggests both a deck of cards and the weeks of the year. Perhaps Tansey is intimating that the history of modernist painting is arbitrary and can be reshuffled at will; perhaps his point is that modernist painting is a house of cards, which is about to collapse. Or perhaps the fifty-two squares mark the completion of the modernist project. However his grid is read, Tansey obviously uses it in a way that differs significantly from the modernists he depicts.

Shifting from the structure to the "substance" of the work, Tansey's criticism of modernist painting deepens. This is a painting that consists of multiple paintings; each painting within the painting is a representation of yet another representation. Tansey appropriates all but one of the images in the painting from magazines like *Life, Popular Mechanics, National Geographic,* and *Soldier of Fortune.* The remaining image is a movie still of Charles McGraw and Marie Windsor. Studies for the painting, which consist of the cut-out pictures, indicate how accurately Tansey has copied the photographs. Each horizontal row of images in the painting is thematically organized. Moving from top to bottom, Tansey considers windows, doors, barriers, surfaces, covers/covering/uncovering, self-reflection/self-exposure, and sight/sighting/insight/blindness. In his examination of the window, for example, he presents alternative interpretations of the picture plane, which has informed painting and criticism since at least the Renaissance. Reading from left to right, the window appears as transparent, illusionistic, open, reflecting, a barrier, blinded, broken, and an open door.[11] Other pictures show workmen

<hr />

11. In a second painting entitled *A Short History of Modernist Painting* (1982), Tansey returns to the theme of the impenetrability of the picture plane. In something approaching a triptych, he represents a woman with

whose brushes and rollers are tools of the construction trade rather than instruments of artists. In one way or another, all of the images in the painting deal with issues of surface and depth or, correlatively, exteriority and interiority. From windows, doors, walls, and floors to sheets, clothes, and skin, Tansey suggests variations of the game hide-and-seek. Many of the people he pictures seem to be looking but not finding. As the picture plane flattens, windows break, doors open, walls fall, the ground is penetrated, clothes are stripped, skin is punctured, heights are scaled, and depths are fathomed. In the richest series of images, the self-referentiality of the work of art is figured in the self-exposure of the human body: a man getting a Japanese tattoo on his chest, a woman getting a chest x-ray, another woman baring her breasts, a man examining facial blemishes in a mirror, a woman clothing herself, and finally a man, being led away between two soldiers, exposing himself. But most puzzling of all is the picture of a woman gazing in a mirror and discovering not her own image but the inverted figure of a child. It is as if the more refined the surface becomes, the less it can be trusted. When depth is surface and inside is outside, everything is upside-down and there is nothing left to hide.

Scattered throughout the grid, there are identifiable traces of artistic practices and, in a few cases, particular artists and specific works of art. From formal abstraction to Minimalist sculpture, from color field to collage, and from monochrome to grid, fine arts appear as images clipped from popular mechanics. A target that could have been painted by Jasper Johns, tiles that could have been laid by Carl Andre, a hole that could have been dug by Robert Smithson or Michael Heizer combine to render the conjunction of images all the more incongruous.

The history of modern painting that Tansey charts seems

a hose, spraying water on a closed window, a man banging his head against a freestanding wall, and a chicken looking at itself in a mirror. In *Modern/ Postmodern* (1980), he combines two black-and-white pictures of a window, one of which is an open door through which one man kicks another in the face, and the other of which is a closed door that a man is trying to kick down.

more like an arbitrary series than a coherent story. When it ends, it is with blindness, not insight. The fifty-second image on the grid pictures a blindfolded man who is carrying a radio—which, incongruously, seems to have two wide-open eyes—in his left hand and feeling his way with an umbrella in his right hand. We will return to the umbrella in a later chapter. For the moment, it is the radio that gives voice to what modernist painting not only leaves out but actually represses. As vision fades, the other senses take over; conversely, as vision dominates, the other senses wither. When critics and artists insist that painting comes to completion in the immediate experience of pure opticality, the work of art becomes an exercise in sensory deprivation. From this point of view, the aesthetic of modernist painting is ascetic or, more precisely, puritanical.[12] Painting, Tansey is suggesting, is not over but has become too limited, too restrictive. By soliciting the return of what modernist art represses, picture making once again becomes possible. In richly textured paintings, he creates pictures too complex to be grasped by vision alone. Borrowing the title of one of Merleau-Ponty's most influential books, Tansey's works establish an intricate interplay between "the visible and the invisible." The senses to which Tansey recalls painting, therefore, are not only sensual but are also mental.

12. Two paintings completed in 1983—*Seven Deadly Sins* and *Four Forbidden Senses*—call for a return of senses too long repressed. The reasons that modernist painters have repressed senses other than vision are as much theological as aesthetic. According to the law of opticality, one can look but not touch, listen, smell, or taste. In the first image in *Seven Deadly Sins,* a woman holds an obviously phallic hose with which she waters a tree while taking a bite out of an apple.

3 Sutures of Structures

Do pictures mean? If so, how? The questions of *whether* and *how* pictures mean is not the same as the question of *what* they mean. Before we ask what a particular picture means, it is necessary to ask whether and how pictures mean.

Tansey is convinced that pictures not only can but *should* mean. He realizes, however, that in the art and criticism of the 1960s and 1970s, the meaning of pictures had been eclipsed in different ways. On the one hand, if a painting is nothing more than a flat surface, meaning collapses in the tautology of self-referential objects; on the other hand, if the materiality of the work of art vanishes into a concept, paintings as such cannot be meaningful. Opticality and conceptuality, therefore, are unable to capture the meaning of painting. In the former, the invisible concept disappears in the visible painting, and in the latter, the visible painting disappears in the invisible concept. In neither case is there a recognition of the complex interrelation between the visible and the invisible that is necessary for the genesis of meaningful paintings. From Tansey's perspective, both of these alternatives are "endgames," which simultaneously mark the closure of a certain trajectory of modernist painting and create new possibilities for artists who once again are willing to put the picture in question. He seeks a third way *between* the oppositional extremes, which for too long had determined the theory and practice of art.

The question Tansey poses at this point in his inquiry is:

How can the visible and the invisible be woven together to create pictures whose complex textures probe the problem of meaning? By shifting his attention to the problem of meaning, Tansey immediately becomes entangled in the issue of what is traditionally labeled the "content" of the work of art. While convinced that method and content are always inseparable, he insists that paintings are about more than how they are produced.

> In the late 1970s, what was particularly attractive about pictorial representation was that one faced an opening and extending realm of content rather than dematerialization, endgames, and prolonged swan songs. Difficulties lay in the long established and increasingly critical isolation of subject matter from art practice. Critical discourse and art education had restricted the notion of content to two pockets coalescing around formal and conceptual poles. To speak about subject matter in a picture simply was not done.

> My feeling was that there was no longer any justification for these restrictions. Pictures should be able to function across the fullest range of content. The conceptual should be able to mingle with the formal and subject matter should enjoy intimate relations with both. (VR 134)

When art no longer is restricted to immediate experience, atemporal formalism, and immaterial concepts, it becomes possible to rethink the subject matter of painting. For this reason, the "end" of representation marks a new beginning for painting. If the conceptual and the formal can mingle in the figurative, pictures might be able to bear the weight of meaning in new and unexpected ways.

During the early 1980s, the question of meaning was hotly debated by philosophers and literary critics. The pivotal issues around which these discussions swirled was once again the problem of representation. The central figure in these controversies was Derrida. While his extensive writings attracted considerable attention, the subtlety and complexity of Derrida's position led to widespread confusion and misunder-

standing. Since many of his followers as well as critics were not adequately familiar with the philosophical tradition from which his work derives, they tended to misread his writings as implying the negation of the very possibility of meaning. While not schooled in the history of philosophy, Tansey, who is a careful and insightful reader, quickly realized that the debates between and among philosophers and literary critics actually repeated arguments artists had been developing for more than two decades. In contrast to postmodern critics for whom the play of signs renders meaning indeterminate, and conservative critics who seek absolute meaning, Tansey maintains that the meaning of pictures is determinate but not absolute. Through his efforts to mediate text and image, he attempts to reintroduce the question of meaning in painting. Mingling representations and figures with concepts and ideas, Tansey creates multidimensional pictures with multiple but not endless meanings. As we have noted and will see in more detail in the next chapter, his approach to representation is considerably more sophisticated than the arguments of critics and artists who summarily dismiss it. In the following pages, we will discover Tansey's understanding of painting and the meaning it bears are equally complex.

Tansey frequently describes both the activity of painting and paintings as "metaphors." However, he never explains exactly what he means by his use of this rhetorical trope to describe painting(s). A clue that helps to clarify Tansey's point can be found in the word itself. A metaphor is, of course, "a figure of speech in which a term is transferred from the object it ordinarily designates to an object it may designate only by implicit comparison or analogy" (*American Heritage Dictionary*). Accordingly, metaphorical language is figurative. Figures, as the etymology of "metaphor" suggests, are sites of transference. "Metaphor" derives from the Greek *metaphreien,* which means "to transfer." If paintings are metaphors and metaphors are sites of transfer or exchange, then paintings might be understood as something like bridges. But what is the meaning of "bridge" in this context?

The figure of the bridge appears at several critical points in Tansey's paintings. In one case, he devotes an entire paint-

ing to a bridge: *Bridge over the Cartesian Gap.* This characteristically reddish orange painting pictures a massive stone bridge with tiny human figures crossing in both directions while carrying everything from a ladder, a briefcase, and a canoe which looks like an umbrella to the kitchen sink. Moving from left to right, silk-screened words gradually come into focus just beneath the surface of the bridge. Close reading reveals in the upper right-hand corner a partially erased title: *Blindness and Insight.* This book, written by Derrida's most influential follower—Paul de Man—exercised considerable influence on Tansey for several years.

In *Blindness and Insight,* Tansey discovered intriguing analyses of problems preoccupying critics at the time as well as resources for his own artistic work. In an essay whose title expresses a literary version of Tansey's reading of the empty formalism of abstract painting, "The Dead-End of Formalist Criticism," de Man offers a richly provocative comment on metaphor. Responding to William Empson's *Seven Types of Ambiguity,* de Man writes:

> What the metaphor does is actually the opposite [of what Empson claims]: instead of setting up an adequation between two experiences, and thereby fixing the mind on the repose of an established equation, it deploys the initial experience into an infinity of associated experiences that spring from it. In a manner of a vibration spreading in infinitude from its center, metaphor is endowed with the capacity to situate the experience at the heart of the universe that it generates. . . . Experience sheds its uniqueness and leads instead to a dizziness of the mind. Far from referring back to an object that would be its cause, the poetic sign sets in motion an imaging activity that refers to no object in particular. The "meaning" of the metaphor is that it does not "mean" in any definite manner.[1]

1. Paul de Man, *Blindness and Insight: Essays in the Rhetoric of Contemporary Criticism* (Minneapolis: University of Minnesota Press, 1983), p. 235.

This crucial insight informs all of de Man's criticism. Since metaphors do not refer to specific objects, the determinability of their meaning seems to vanish in a fathomless abyss. In this way, de Man's interpretation of metaphor appears to lead to precisely the loss of meaning that Tansey is attempting to overcome. Careful inspection suggests that *Bridge over the Cartesian Gap* both borrows from and stands in critical tension with *Blindness and Insight*.

In developing his critique of de Man, Tansey does not try to revive representation by reinstating an oversimplified account of meaning in terms of objective reference. While quoting de Man, the argument articulated in this painting is actually closer to Derrida's point of view. Even though both supporters and critics often identify the positions of Derrida and de Man, their accounts of what is labeled "deconstruction" differ in many important ways. One of their most serious disagreements concerns the interrelated questions of certainty and uncertainty. De Man, it seems, is always more certain about his uncertainty than Derrida. Though running throughout their writings, this difference is particularly evident in the dialogue with and response to de Man that Derrida develops in "White Mythology: Metaphor in the Text of Philosophy." Derrida's aim in this essay is, first, to show that throughout the Western tradition philosophy has been consistently suspicious of tropological language and, then, to demonstrate that philosophy unwittingly reinscribes the very rhetorical strategies it seeks to exclude. The philosophers of whom Derrida is most critical regard metaphorical discourse as acceptable, if at all, only provisionally. Like a representation that must be erased to reveal the thing itself or uncover the concept, metaphor is a bridge that must be lifted once one reaches the far shore, the promised land of meaning.

Metaphor, therefore, is determined by philosophy as a provisional loss of meaning, an economy of the proper without irreparable damage, a certainly inevitable detour, but also a history with its sights set on, and within the horizon of, the circular reappropriation of literal, proper meaning. This is why the philosophical evaluation of metaphor always has been

45

ambiguous: metaphor is dangerous and foreign as concerns *intuition* (vision or contact), *concept* (the grasping or proper presence of the signified), and *consciousness* (proximity or self-presence); but it is in complicity with what it endangers, is necessary to it in the extent to which the de-tour is a re-turn guided by the function of resemblance (*mimesis,* or *homoiosis*), under the law of the same. The opposition of intuition, the concept, and consciousness at this point no longer has any pertinence. These three values belong to the order and to the movement of meaning. Like metaphor.[2]

From Plato to Hegel and beyond, philosophy seeks to return to the proper by turning from the improper, which is always figurative. Figures—be they visual or verbal—inevitably deceive because they never mean exactly what they say. Tropes, in other words, always twist the truth.[3]

For Derrida, the philosophical effort to establish truth by setting language straight is bound to fail. Concepts, from which philosophers claimed to have purged improprieties, always bear traces of the twists and turns in and through which they take form. Meaning, therefore, is never proper. Inasmuch as discourse is inevitably tropological, there is no escaping metaphor. Since everything is in motion, transition, transit, there is only transfer, never final arrival. It is, therefore, as impossible to avoid metaphor as it is to flee time. For temporal beings, meaning is never completely certain but always in-formation and is, thus, both incomplete and improper. To claim that meaning is improper is not, however, the

2. Jacques Derrida, *Margins of Philosophy,* trans. Alan Bass (Chicago: University of Chicago Press, 1992), p. 270. If one substitutes *Vorstellung* for "metaphor" in this passage, it becomes clear that the metaphorical structure Derrida is describing is virtually identical to the speculative relationship between representation and concept that forms the foundation of Hegel's philosophy. As *Vorstellung* gives way to *Begriff,* so metaphor is left behind when the concept is fully articulated. In this way, Hegel's speculative philosophy gives systematic expression to the long-standing dream of revealing pure knowledge untainted by representations.

3. "Trope" derives from the Greek *tropos,* whose stem, *trep,* means to turn.

same as to insist that "no meaning is possible at all." Always suspended in medias res, we can be no more certain about our uncertainty than our certainty. If time is the medium of existence, nothing remains secure. In the absence of fixed referents and stable ground, meanings multiply as meaning withdraws. The problem, it seems, is less the lack of meaning than the excessive proliferation of meanings. As if to underscore this point, Derrida concludes "White Mythology" with lines whose meanings keep expanding:

> No language can reduce itself to the structure of an anthology. This supplement of a code which traverses its own field, endlessly displaces its closure, breaks its line, opens its circle, and no ontology will have been able to reduce it. Unless the anthology is also a lithography. Heliotrope also names a stone: a precious stone, greenish and streaked with red veins, a kind of oriental jasper.[4]

When the code is cracked in a way that breaks its line, displaces its closure, and opens its circle, the medium becomes the message and transfer is endless. In this interstitial space and intermediate time, questions linger: What is the stone Derrida deems so precious and what circulates in its red veins?

Perhaps it is the stone depicted in *Bridge over the Cartesian Gap* whose red veins are formed by lines Tansey draws from *Blindness and Insight.* Here as elsewhere the title is not extraneous but is folded into the work of art. Inasmuch as modern philosophy begins with Descartes's *Discourse on Method* (1637), the "Cartesian Gap" serves as something like a trope for all the oppositions constitutive of modern thought. Bridging this gap, therefore, would recast the contours of modernism. To bridge, however, is not necessarily to unite. More complicated than usually realized, the logic of the bridge cannot be graphed on the grids of Cartesian space. In an effort to refigure the meaning of painting, Tansey attempts to articulate the strange logic of bridging.

4. Derrida, *Margins of Philosophy,* p. 271.

While the oppositions opened and reinforced by the Cartesian gap are many—mind/body, spirit/matter, thinking/feeling, reason/emotion, freedom/determinism, inside/outside, surface/depth, theory/practice, and so on—Tansey is particularly interested in the ways in which concepts or ideas intermingle with materials to create paintings that are meaningful. Variations of this problem are, as we have seen, as ancient as Plato's philosophy. But Tansey's approach recasts old questions in a contemporary context to generate new insights. He realizes that if paintings are to be meaningful, they must be more than self-referential objects that occasion immediate experience. Both the presence of the literal object and the immediacy of the present moment are actually meaningless. Neither an object that refers only to itself nor an experience that does not point beyond itself can carry meaning. Since meaning requires relation, it cannot be im-mediate but must always be mediated. For example, B cannot be B without its relation to A and C; nor can A be A or C be C without relation to B and C, and A and B respectively. A, B, and C are interrelated in such a way that each becomes itself in and through the others. The medium of this interrelation is the process of mediation, which negotiates differences in a way that establishes identities. This activity of negotiation, it is important to note, does not necessarily overcome oppositions by establishing a unifying synthesis. To the contrary, the medium of negotiation involves a different and more complex bridging that simultaneously brings together what it holds apart and holds apart what it brings together. This is the alternating rhythm at play in Tansey's red bridge.

With people crossing in both directions, *Bridge over the Cartesian Gap* is a two-way bridge. While the painting seems utterly clear, the closer one looks, the stranger the bridge becomes. It seems to be suspended in thin air and thus appears to bridge nothing and lead nowhere. Neither joining two banks nor spanning a valley, the bridge is something like a site of ceaseless transfer or a medium as such. In the absence of near and far shores, only the between of the bridge remains. As the figure of the medium in which opposites are trans-

ferred without either falling apart or collapsing together, the bridge might be understood as a metaphor for painting as a metaphorical process.[5]

In his search for the meaning of meaning at work in painting, Tansey draws on directly and indirectly the ongoing critical debates in philosophy and literary criticism. As always, he modifies what he appropriates. If the arguments of philosophers and literary critics are to be useful to a painter, the verbal must be extended to the visual. For pictures to be meaningful, Tansey argues, idea and image have to intersect. "In my earlier paintings," he explains, "my primary concern was to find out how to bring image and idea together. I was beginning with simple oppositions—male/female, artificial/natural, static/mobile, mythic/scientific, present/past. I found that oppositions of light and dark in monochrome could act as a formal analogue to conceptual oppositions" (VR 128). Tansey's strategy of relying on binary oppositions to organize his work is indebted to his understanding of structuralism. Even though much twentieth-century philosophy and culture were transformed by what is often described as "the linguistic turn," it was the linguistic ruminations of the French anthropologist Claude Lévi-Strauss that had the most significant impact on the social sciences, arts, and humanities during the 1960s and 1970s. Lévi-Strauss both continues the French sociological and anthropological tradition that begins with Emile Durkheim and Marcel Mauss and shares many of the concerns of phenomenological philosophy and French versions of psychoanalysis. His distinctive contribution, however, results from an appropriation of Ferdinand de Saussure's analysis of language for the purpose of interpreting society and culture as a whole. Society and culture, according to Lévi-Strauss, are structured like a language. By uncovering the principles, rules, and codes through which these "linguistic"

5. It is helpful to recall that "metaphor" derives from the Greek *metapherein* (to transfer), which combines *meta* (involving change) and *pherein* (to bear). The two stems of metaphor are *medhi* (middle, between) and *bher* (cut, pierce; break). Far from merely uniting, the etymology of "metaphor" suggests an interstitial break or a cutting medium.

structures operate, it is possible to describe how sociocultural systems work. While it is unnecessary to go into the details of the arguments of Saussure and Lévi-Strauss in this context, several of their most important conclusions must be noted if we are to understand Tansey's consideration of the meaning of painting(s).

In his *Course in General Linguistics,* Saussure makes three points that are crucial for both Lévi-Strauss and Tansey. First, he insists that signs are arbitrary conventions. Since there is no necessary relation between signifiers and signifieds, signs have no essential meaning independent of the networks within which they are inscribed. Second, in what is perhaps the best-known line from his work, Saussure argues that in any system of language "there are only differences with no positive terms."[6] The particular elements of a language do not exist prior to or independent of the relational networks that constitute the system. To the contrary, differential relations, as we have seen, define the identity of the elements in a language system. Third, the differential or diacritical nature of signs means that a sign never points beyond itself to an autonomous concept that it expresses or to an independent idea that forms its essence. Within the structure of the sign, the signifier refers to a signified that is itself formed by its relative place within a differential system of signs.

Lévi-Strauss sees in these and related principles the kernel of the foundational rules regulating every society and all culture. Society, from his point of view, is a complex network of transfer and exchange that displays a stable structure. Borrowing Saussure's account of the differential character of linguistic identity, Lévi-Strauss argues that the universal structure of structure is binary opposition. Everything assumes its identity in and through the relation to its own opposite. When translated from the formalism of structural principles to the specificity of semantics, this insight implies that meaning is generated by the interweaving

6. Ferdinand de Saussure, "Course in General Linguistics," in *Deconstruction in Context: Literature and Philosophy,* ed. Mark C. Taylor (Chicago: University of Chicago Press, 1985), p. 141.

of differences and oppositions. In a circle that sometimes seems vicious, cultural meanings fabricated in differential networks inform social systems of exchange, which, in turn, generate cultural symbols. To understand these dynamics as precisely as possible, Lévi-Strauss produces intricate charts, graphs, and diagrams, which serve as visual aids. He then proceeds to plot the elements comprising social and cultural systems along horizontal and vertical axes in a way that invariably displays structures of binary opposition. To read the text of culture, Lévi-Strauss argues, it is necessary to comprehend the meanings produced in these structural frameworks.

To the eye tutored by twentieth-century art and architecture, Lévi-Strauss's charts, graphs, and diagrams look like the classic modernist grids Tansey uses as the formal structure of some of his most important early works. After reading Lévi-Strauss, Tansey begins experimenting with the use of grids to generate the subject matter of his paintings. Later, in order to come to a better understanding of how meaning forms, Tansey actually designs elaborate Lévi-Straussian grids. These diagrams are at first simple but quickly become quite complex. In one of his earliest efforts, he literally frames the empty space of what will become the picture with a series of questions. Each question is stated briefly and framed carefully. These frames folded within frames frame the questions that Tansey's work addresses. The problems he charts in these elaborate diagrams recall past preoccupations and anticipate future work. Tansey questions the structure of temporality, the function of representation, the interplay between words and images, the aesthetic significance of concepts, the connection of the invisible and the visible, the relationship between the handmade and mechanically reproduced objects, and the differences among various artistic media. As Tansey's reflections unfold, his interpretive grids become more finely textured. Three years after his initial effort, he complicates the framework of his reflection by multiplying the frames of his analysis. The result is an intricate diagram consisting of nested frames.

Tansey organizes his classificatory grid, which forms the

outermost frame, according to the following principles: Oppositions, Problems, Motifs, Language Motifs (Devices), and Modes of Transformation. In the middle of this frame, he places another frame, which defines Meta-Themes. On close examination, it becomes clear that the oppositions Tansey identifies structure the problems, motifs, and themes he considers. His list of binary oppositions is primarily comprised of permutations and combinations of categories central to the debates between structuralists and poststructuralists: raw/cooked, constructive/deconstructive, signifier/signified, centered/decentered, artificial/natural, certainty/doubt, semiological/sexual, visible/invisible, clear/obscure, original/ copy, ornamental/real, actual/simulation, control/random-chaotic, linear/nonlinear, complex/simple, surface/depth, hiding/exposing, and so on. Such oppositions cross and crisscross to generate the problems and motifs that become the subject matter of Tansey's paintings. The metathemes graphed include titles of specific works past and future: Valley of Doubt, The Source, Myth of Depth, Achilles and the Tortoise, Forward Retreat, Triumph over Mastery, Judgment of Paris, The Key, The Conversation, and Cartesian Gap. The more intriguing metathemes, however, suggest questions that run through all of Tansey's work: Gap Probing, Gap Measuring, Blindness and Insight, The Source (Origins), The Present, The Presentation, Stopping Time, Arts of the Veil, Border Dispute, Perspective Crisis, Onset of Chaos, and Capturing the Real.

But even this intricate structural device is not sufficiently complex to generate the questions Tansey struggles to pose and probe. In collaboration with Fritz Buehner, he bends lines that once seemed straight to transform his grids into a "Color Wheel." In its final version, this device, which is made of plywood and wood veneer and measures thirty-eight by forty-eight by forty-eight inches, consists of three concentric wheels with words carved in their surfaces. In the innermost circle there are nouns, in the middle, participles, and, along the outer edge, nouns or brief phrases. Each of these circles can be rotated independently of the other two. As the wheels turn, the nouns on the inner wheel and

the participles on the middle wheel combine with the nouns and phrases on the outer wheel to create subject-participle-object constructions. The 180 entries on each ring, which suggest the degrees in a triangle, can be combined to form 5,832,000 possible phrases. Tansey uses the juxtapositions created by the wheel to formulate new ideas and metaphors for his pictures. When the lines of the grid are reinscribed in the circles of the wheel, an important change occurs. The rotating wheels generate a certain space for the aleatory, which the stability of grids excludes. With the invention of this device, Tansey adds something like a roulette wheel to the deck of cards with which he narrates the short history of modernist painting. While structure does not simply dissolve in these games, it now is punctuated by chance. Like the deck of cards that is constantly reshuffled, these wheels of chance keep the game going by keeping meaning in play. As Tansey spins his wheels, the questions his paintings investigate proliferate.

Shifting from the analogy of card games and roulette wheels yet sticking with games of chance, Tansey's color wheel might be understood as something like a slot machine. Sometimes when the wheels stop spinning, the combination is a winner. When this occurs, Tansey has the germ of what might eventually become a painting. He nourishes this germ by creating yet another grid on a wall-sized bulletin board in his studio. The phrase produced on the color wheel provides a framework within which Tansey develops his painting. Each work is the product of prolonged reflection in the course of which he creates colossal collages by juxtaposing texts, notes, photographs, photocopies, sketches, and drawings. The wall becomes something like an infinitely expanding game board where the pieces are always changing and nothing is fixed. The only rule governing the game Tansey is playing is that meaning emerges in and through the interplay of different elements. His image for this interplay is a crossroads where, in Merleau-Ponty's terms, the visible and the invisible intersect to produce pictures. The crossroads, like the bridge, is the site of exchange and transfer where everything is in transition. As we shall see, this point of exchange is not only where

53

meaning emerges but can become the site of conflict and crisis where meaning collapses.[7]

Tansey's initial efforts to incorporate Lévi-Strauss's insights into his paintings involve more or less straightforward representations of structuralism's oppositions and grids. Drawing on his early experience as an illustrator, he translates structuralist principles into images. The most graphic example of this tendency is *Iconograph I*. In this work, Tansey uses a Lévi-Straussian grid to explore the relation between the natural and the artificial. Repeating the gridlike structure of other works, *Iconograph I* consists of nine squares. The image in the upper left corner suggests that the relation between the natural and the artificial involves the philosophical and artistic problem of mimesis. A man and an ape strike the same pose: cupping their left hands near their mouths, they shout into the jungle. Like so many of Tansey's images, this picture raises questions without providing answers. Since it is impossible to know whether the man is aping the ape or the ape is aping the man, it is not clear whether culture imitates nature or nature imitates culture. Every image in *Iconograph I* confounds the relation between the artificial and the natural: tree trunks gradually become totem poles, the outline of a cave by the sea looks suspiciously like the profile of George Washington, an armed soldier appears to be a walking tree, a potted plant is perched on a pedestal in an overgrown garden, a greenhouse encloses a variety of tropical plants, tiny human figures cling like tiny bugs to the face of George Washington carved in the stone of Mount Rushmore, a machine covered by creeping vines sits in the midst of a garden, and something that looks like either a satellite or an alien spacecraft has just landed or is about to take off on an open under a starry sky.

7. Tansey is, of course, keenly aware of the fact that the opposition between subject matter and technique is one of the contrasts that most needs to be refigured. Just as titles are not extrinsic supplements but form the "substance" of his works, so technique is, in one way or another, the subject matter he constantly probes. To underscore the inseparability of *what* he paints and *how* he paints, Tansey coins the term "technophor." Technophoric processes cultivate networks of exchange between and among various visual orders by bridging different techniques.

From primitive jungles to futuristic space probes, it remains unclear where the line between nature and culture or the natural and artificial should be drawn. As Tansey's work develops, it is precisely this enigmatic boundary between what Lévi-Strauss labels "the raw and the cooked" that increasingly draws his attention. Later considerations of the ways in which the intersection of opposites generate meaning are considerably less didactic and more subtle. In one of his seminal works, *White on White,* Tansey appropriates the title from Kasimir Malevich's well-known Suprematist composition. While Malevich's abstract painting consists of two superimposed white monochromatic squares, Tansey's work pictures a group of Inuit and Bedouin, accompanied by sled dogs and camels, facing each other in a snowstorm and/or sandstorm that threatens to create a whiteout. As is his custom, Tansey borrows the images from a magazine, in this case, *National Geographic.* Instead of a clearly delineated grid, he structures this painting along invisible horizontal and vertical axes that intersect just to the right of center. The wind blowing in opposite directions suggests the intersection of the opposites depicted in the painting: Inuit/Bedouin, dog/camel, arctic/desert, snow/sand, earth/sky, cold/hot, east/west, and north/south. In a visual pun, Tansey suggests that these opposites constitute polarities that cannot be reconciled. The decentered center of the painting is a gap or rift.

This is not the first time Tansey ventures into the gap, nor will it be the last. In a 1986 painting entitled *Doubting Thomas,* he pictures a man kneeling beside his car, sticking his hand into a fault that has opened in the middle of the highway, while a statuesque woman waits in the car with her hand provocatively fondling the gearshift. The straight white line on the road and the crooked line of the fault intersect to form a cross, which defines the crumbling gridlike structure of the painting. This latter-day doubting Thomas is confronting the crisis of a wor(l)d in which secure foundations are crumbling. "In my later work," Tansey explains,

the idea of crisis was tempered and extended to rift and resonance. For instance, a picture might be de- 55

coded by distinguishing rifts (contradictions, discrepancies, implausibilities) from resonance (plausible elements, structural similarities, shared characteristics, verifications). In fact the notion of rift and resonance is fundamental to the picture-constructing process as well. Take, for example, *White on White*. The monochrome lateral washes of paint suggest (resonate) with photographic plausibility both snowstorm and sandstorm and, as monochrome does not verify heat or cold, the unity of space is maintained. The unified space affirms the proximity of the Bedouins and Inuits, but their identities, their dress, modes of transportation (huskies and camels) suggest different climates and evidence of the windblown fur and clothing attests to winds blowing in opposite directions. If this evidence is affirmed, there would be an invisible rift down the center of the picture, where distant continents collide. Furthermore, the Inuits and Bedouins may be trying to determine exactly where the invisible rift lies. (VR 134)

It is not only the Inuit and Bedouin who are trying to ascertain where the invisible rift lies. Tansey is also searching for the elusive rift that creates the space of (the) painting. His exploration of this no-man's-land is not without a certain danger.

When opposites face off, violence always threatens to erupt. "The more I tried to purge violence," Tansey confesses, "the clearer it became how conflict exists on all levels of content, though in unexpected registers. The key was to transform it into productive oppositions, equivocations, inquiries, contrasts, gradations, to find other structures of distinctions, mixings, pulsations, oscillations, weavings, foldings" (MT 53). The weavings and foldings that Tansey fabricates become the textures of his work. As we have already begun to realize, these textures render his paintings textual.

The textuality of the work of art creates rifts in the structures that generate meaning. Though the insights of structuralism proved useful as Tansey probed the ways in which meaning is figured in pictures, he eventually is forced to acknowledge that this method of analysis is plagued by some

of the same problems he saw in modernist painting. From his earliest use of the grid, Tansey realizes that such a structure can function to negate temporality. By delineating the way in which meaning is articulated through the interplay of opposites, structuralism uncovers rules, principles, and codes that are supposed to be universal and unchanging. From a structuralist point of view, the temporal flux of meanings is underwritten and thus occasioned by atemporal structures. These structures function like inverted Platonic forms, which are the abiding essence of becoming. Structuralism's difficulties in accounting for the role of time in the play of signification are compounded by the implicit self-referentiality of its foundational structures. If the sign is always the sign of a sign, the structure of signification folds back on itself in such a way that ostensible exteriority is internalized to form a self-reflexive circuit. Like the self-reflective images of Pop Art and Photo-Realism, the structuralist sign points to nothing beyond itself. When all reference is self-reference, there is nothing outside the image or sign. The play of signs becomes as seamless as a web without holes, gaps, or rifts.

Atemporal foundational structures and self-referential systems of signification combine to reinscribe Tansey's "narrow present." Structuralism's privileging of the present is evident in its concentration on synchronic structures to the exclusion of diachronic developments. While effectively deciphering the intricacy of networks of exchange that constitute cultural symbols and practices, structural analysis is unable to account for either the origin or historical development of these systems. Structuralism tries to exclude temporality by leaving it unfigured. But what is left out is not necessarily absent, even though it is not exactly present. When read through the lens of poststructuralism, the rifts and folds inherent in structures imply an inescapable temporality that exceeds the present. One of the traces of this strange time is the frame.

As we have seen, the figure of the frame plays a crucial role in Tansey's appropriation of the structuralist interpretation of meaning. In his effort to render painting meaningful, Tansey literally frames his questions in terms of structuralism. He does not, however, attempt to define the frame as such 57

or to describe precisely how frames work. What, then, is a frame, and what is frame work?

This question is deceptive in its simplicity. A frame is, of course, "a basic skeletal structure designed to give shape or support" (*American Heritage Dictionary*). When used in constructing something like a house, this structure is an endoskeleton; when used for something like a painting, the structure is an exoskeleton—or so it would seem. But when the frame is in question, it is difficult to determine what is inside and what is outside. Rather than being on one side or the other, the frame is neither inside nor outside. Where, then, Derrida queries, "does the frame take place. Does it take place. Where does it begin. Where does it end. What is its internal limit. Its external limit. And its surface between the two limits."[8] These questions frame the first section of Derrida's *The Truth in Painting,* whose title, which is itself a frame, is borrowed from Cézanne.[9]

Though seemingly extraneous, the question of the frame is pivotal for the work of art. Indeed, the frame is something like a pivot on which the question of art turns. Derrida associates this pivot with the fold (*le pli*). We have previously discovered the fold in the twist through which both reference and reflection turn back on themselves to become

8. Jacques Derrida, *The Truth in Painting,* trans. Geoffrey Bennington (Chicago: University of Chicago Press, 1987), p. 63.

9. Explaining the source of the title of this book, Derrida writes:
> *The Truth in Painting* is signed Cézanne. It is a saying of Cézanne's.
>
> Resounding in the title of a book, it sounds, then, like a due.
>
> So, render it to Cézanne; and first of all to Damisch, who cites it before me, I shall acknowledge the debt. I must do that. In order that the trait should return to its rightful owner.
>
> But the truth in painting was always something owed.
>
> Cézanne had promised to pay up: "I OWE YOU THE TRUTH IN PAINTING AND I WILL TELL IT TO YOU" (to Emile Bernard, 23 October 1905). (Ibid., p. 2)

As we shall see in the next chapter, the philosophical reading of Cézanne running from Merleau-Ponty to Derrida plays an important role in the development of Tansey's investigation of painting.

self-referential and self-reflexive. With the help of Derrida, it is now possible to discern how folding interrupts the apparently closed circuits of self-reference and self-reflection. Intentions to the contrary notwithstanding, from Plato and Hegel to Saussure and Lévi-Strauss, the return *of* the fold forever disrupts the return *to* the fold. In the introduction to *The Truth in Painting,* Derrida writes:

I write four times here, *around* painting.

The first time I am occupied with folding the great philosophical question of the tradition ("What is art?" "the beautiful?" "representation?" "the origin of the work of art?" etc.) on the insistent atopics of the *parergon:* neither work (*ergon*) nor outside the work [*hors d'oeuvre*], neither inside nor outside, neither above nor below, it disconcerts any opposition but does not remain indeterminate and it *gives* rise to the work. It is no longer merely around the work. That which puts it in place—the instances of the frame, the title, the signature, the legend, etc.—does not stop disturbing the *internal* order of discourse on painting, its works, its commerce, its evaluations, its surplus-values, its speculation, its law, and its hierarchies.[10]

In this complex text, Derrida provides the kernel of his answer to the question of the frame and its work. The space of the frame, he argues, is the marginal site or nonsite staked out by the neither/nor: "neither work (*ergon*) nor outside the work [*hors d'oeuvre*], neither inside nor outside, neither above nor below." Neither a part of nor apart from the work, the frame is a necessary appendix or indispensable supplement. Without being integral to *l'oeuvre d'art,* the frame nonetheless "gives rise to the work." When the frame works, it is nothing less than "the origin of the work of art."[11] Insofar as the work of art necessarily involves distinctions such as form/matter,

10. Ibid., p. 9.
11. Derrida's implied reference is to Heidegger's well-known essay by the same title. In the last section of *The Truth in Painting,* Derrida develops a detailed reading of the argument Heidegger presents in this extremely influential work.

figure/ground, light/darkness, and so on, it takes as its point of departure the work of the frame. These distinctions are contrasts whose specific effects are a function of the way in which differences are framed. It is important to realize, however, that the frame is not exactly an origin in the usual sense of the term. Far from a source that once was present, the frame traces a withdrawal that has always already occurred and yet never ends. Since it can neither bear nor do without the frame, the work of art must, impossibly, include what it lacks. Commenting on Kant's account of the beautiful in the *Third Critique,* Derrida clarifies his often perplexing view of the frame.

What does the lack depend on? What lack is it?

And what if it were the frame. What if the lack formed the frame of the theory. Not its accident but its frame. More or less still: what if the lack were not only the lack of a theory of the frame but the place of the lack in a theory of the frame.

Edge [*arête*]/lack[12]

Structuralism lacks a theory of the frame. This lack is not accidental but is a strategic exclusion through which structuralism defines itself. If the metastructure informing every structure is binary opposition, there is no place for the neither/ nor of the frame. Structuralism, in other words, *cannot* conceive the frame, yet presupposes precisely the neither/nor figured by the frame. The neither/nor of the frame is implied (*im-pli-qué*) by but not included within the binary oppositions of structures.[13] Thus, every binary structure entails something it cannot comprehend. For oppositions to be articulated, they

12. Derrida, *The Truth in Painting,* pp. 42–43.

13. It is important to note the way in which the notion of the fold and folding is at work in the etymology of some of the words that are central to this analysis. "Imply," for example, derives from the Old French *emplier,* which comes from the Latin *implicare.* As I have already stressed, the French word for "fold" is *le pli* or *plier.* "Complex," "complicate," and "complication" also "imply" folding, or, more precisely, braiding. "Complex" can be traced to the Latin *complexus,* past participle of *complecti, complectere,* to entwine (*com,* together + *plectere,* to twine, braid). The stem of these words, *plek,* derives from the Latin *plicare,* to fold. In chap. 5, I will examine the role the notion of complexity plays in Tansey's art.

must be framed in and through something that eludes the structure of opposition. This frame is the margin of difference, the border of differentiation, and the limit of differing. The work of the frame simultaneously locates oppositions and dislocates their structure.

When understood in this way, the frame forms the suture of structure. A suture is "a seamless joint or line of articulation," which, while joining two surfaces, leaves the trace of their separation. If this margin of difference is erased, structures collapse into undifferentiation. While a structure without seams is no structure at all, a seam can never be properly structured. In a manner reminiscent of bridging, which brings together what it holds apart and holds apart what it brings together, suturing is the interplay of mending and rending through which the texture of structure is fabricated.

In 1992, Tansey explicitly turns his attention to the question of the frame when he decides to stitch an appendix to the catalog accompanying a major exhibition of his work. This supplement consists of three suites of graphite drawings entitled *Wheels, Frameworks,* and *Nocturnes.* The *Frameworks* suite, strategically located between *Wheels* and *Nocturnes,* includes nine drawings that present variations on the theme of the frame and its work. Some of these drawings recall past works, others anticipate future works. In this context, the most interesting drawing in the *Frameworks* suite is *The Raw and the Framed,* which pictures Lévi-Strauss, standing in what appears to be a palatial Parisian museum or art gallery, inspecting a painting with a decorative gilded frame. Though the room seems secure, its walls are fragile. The museum or gallery appears to be subterranean; just beyond its outermost edge, miners equipped with hard hats and heavy equipment are carving a tunnel through rock. As if to combine sculpture and painting, they gather the debris from their drilling and place it on a conveyor belt where it is pressed into framed pictures. The work of art takes shape by passing through the framework that keeps the cave from collapsing. Lévi-Strauss, however, does not realize that what he and his nameless companion take to be an original painting has actually just rolled off the assembly line.

Tansey's ingenious drawing inscribes and subverts the oppositions that Lévi-Strauss's system frames. The work is structured by its horizontal axis: the left/right opposition indicates a series of contrasts that form the subject of the drawing—raw/cooked, unfinished/finished, nature/culture, darkness/light, and cave-basement/museum-gallery. But the most important opposition figured in the work is depth/surface. Tansey translates the vertical coordinate of depth/surface into the horizontal axis left/right. Whether read from left to right or right to left, *The Raw and the Framed* suggests that the work of art emerges through the interplay of countless frames. The meaning of the drawing—and of everything else—is always a function of the work of frames. But no framework is exhaustive and thus meaning is never complete. Since Lévi-Strauss ignores the frame even while scrutinizing the work, the structural analysis he develops can never fully grasp the complex textures of art. Sutures of structures are traces of seams that can never be erased. Tansey now faces the challenge of creating seamy paintings. How can the seam be drawn? The border painted? The gap figured?

4 Painting Under Erasure

In 1990, Tansey introduced words as figural elements in his paintings. While this practice had become widespread in the wake of Greenberg's insistence on the separation of visual and verbal arts, Tansey's appreciation for the critical and theoretical implications of the relation between words and images lends added significance to his textual strategies.[1] As we have already observed, his experiments with various techniques of layering create textured works that are more profound and complex than the flat surfaces idealized in so much modernist painting. By evoking textures that cannot be apprehended by the eye alone, Tansey tries to break the spell of opticality.

1. This is not to imply that the incorporation of words in visual works by other artists is any less sophisticated. From Barbara Kruger's inclusion of the printed word and Jenny Holzer's appropriation of the electronic word for sociopolitical criticism to Arakawa and Madeline Gins's use of writing to investigate "the mechanism of meaning," language is deployed in a variety of ways by contemporary artists. Though their interests and intentions are different, all of these artists share an appreciation for the visual significance of graphic designs. For helpful elaborations of this important issue, see W. J. T. Mitchell, "Word and Image," *Critical Terms for Art History,* ed. Robert S. Nelson and Richard Shiff (Chicago: University of Chicago Press, 1996), pp. 47–57; W. J. T. Mitchell, *Picture Theory: Essays on Verbal and Visual Representation* (Chicago: University of Chicago Press, 1994); and Harrison, *Essays on Art and Language.* I have considered aspects of the relation between words and images in the work of Arakawa and Madeline Gins as well as David Salle in *Nots,* pp. 96–121; 166–211.

In this method of painting, texture replaces color as aesthetic vehicle. Instead of the composing of relations of color, there are interactions of textures. The reading of textures, unlike the immediate optical sensation of color, involves the association of visual appearance with the memory of tactile sensation. . . . By contrast to the immediate opticality of color, the reading of texture involves interactions of time, memory, touch, and sight. There is also a built-in narrative element in that texture, in a sense, is the fossilized record of action, both natural and cultural. Examples are geological strata, a repeatedly marked text, an eroded surface, a piece of textile, a painting with indexical marks. Texture is the trace of events. (VR 128)

The importance of stones and rocks has been evident in some of the paintings we have considered. In this passage, Tansey suggests the reasons for his fascination with geological formations. In the faults and fissures of things that seem as solid as rock, he discerns a strange logic that calls into question the principles of self-referentiality and self-reflexivity. By probing the implications of surfaces that seem to know no end, it becomes possible to detect traces of a past that simultaneously eludes and renders possible representation. The texture of painting is the vestige of an event that is never present but always already past. Tansey's obsession with rocks is, at least in part, a result of his commitment to create timely paintings. Presence and immediacy slip through the cracks and crevices of his paintings into a past that remains forever unfigurable.

One of the earliest pictures in which Tansey incorporates silk-screened words is *Under Erasure*. In this painting, he pictures a towering waterfall cascading over a stone cliff, streaked with lines of partially erased words interrupted by faults running through the rock. In the top left corner above the waterfall stand two cows, reminiscent of the cow that gazes at its painted image in *The Innocent Eye Test*. Beneath the cows it is possible to detect the faint trace of the word "Text" etched in stone. In the lower right corner, there is an overlook with mounted binoculars for viewing the falls. The

strata forming this rocky observation point barely reveal the words *sous rature.*

Under Erasure is a subtly complicated painting in which Tansey both expresses his debt to, and suggests misgivings about, Derrida's influential works. While Derrida's writings form the point of departure for some of Tansey's important paintings, he is never content merely to translate critical texts into visual images.[2] His appropriation of deconstruction is considerably more sophisticated. Tansey, in effect, turns deconstruction back on itself by using Derrida's texts to refigure what they tend to erase. By the time Tansey completed *Under Erasure, sous rature* had become something of a cliché in critical discourse. Nevertheless, Tansey realizes that the pivotal notion of erasure is even more important than Derrida and his followers sometimes realize. Situated in the lower right corner but tilted toward the upper left corner, the spyglass allows a close reading of the multiple layers of the painted "Text." The location of the binoculars is no less significant than their position. The instrument that allows this close reading of the picture is precariously perched on an over-look, which not only points to the blindness that haunts both *Blindness and Insight* and *Memoirs of the Blind* but also raises a question neither de Man nor Derrida can answer: What does deconstruction itself overlook?

To answer or attempt to answer this question would be to deconstruct deconstruction by figuring what it cannot figure. It should be evident that this critical gesture does not represent a simple break with deconstruction; to the contrary, Tansey has learned his lessons so well that he is able to extend the practice of deconstruction in ways Derrida never imagined. While he eventually moves beyond what might be described as something like a deconstructive perspective, the significance of Tansey's recent paintings cannot be understood apart from his abiding debt to Derrida. It is, therefore, necessary to consider further aspects of Derrida's complex position

2. Any such direct illustrative tactic would be an example of precisely the simplistic understanding of representation that Derrida criticizes and Tansey resists.

before proceeding to a consideration of Tansey's use of deconstructive texts in his art.

As we have begun to see, Tansey discovers in Derrida's reading of Western philosophy resources for his own criticism of modernist painting. In formulating an interpretation of what Heidegger labels the "onto-theological tradition," Derrida develops an innovative account of writing that bears directly on the problem of painting.[3] This emphasis on the notion of writing is, in part, a response to the role it plays in Plato's thought. Initiating a pattern that becomes dominant in the West, Plato establishes a hierarchical relationship between speech and writing. The criterion he uses to discriminate between them is the principle of presence or, more precisely, self-presence. Speech seems to preserve a degree of self-presence between speaker and word that is lost in writing. In terms of our previous analysis of modernist painting, speech appears to be more immediate than writing. From Derrida's point of view, the search for immediacy represents a futile— even pernicious—effort to escape the strictures of time and limitations of space. Since every present and all presence inevitably entail a certain absence, immediacy is forever deferred.

Plato realizes that the problems he sees in writing are even more pronounced in painting. The line supposedly separating written word and visual image is not, however, always clear. By claiming to represent ideas or concepts in material media, writing and painting threaten to "infect" or "pollute" the purity of reason. Plato underscores the similarity between the dangers posed by words and images by using the same term to designate both writing and painting: *pharmakon.* Elaborating the importance of this point, Derrida explains that

3. While it is not necessary to examine the details of Heidegger's and Derrida's analyses of onto-theology in this context, it is important to note that the distinguishing feature of the multiple strands in this complex tradition is the identification of being with presence. Inasmuch as to be is to be present, that which is absent or not present does not exist. This ontology of presence presupposes a privileging of the temporal modality of the present. For onto-theology, being and time intersect to form a present in which presence is undisturbed by absence.

the writer as well as the painter is a *pharmakeus* who, as an "illusionist" and "technician of sleight-of-hand," tries to "bewitch" reason by passing off representations for "the real thing." But the power of the *pharmakon* is not limited to its deceptive trickery. A careful consideration of Plato's text, Derrida maintains, discloses that the pharmacological danger is considerably more subtle than the casting of magic spells. If the *pharmakon* were simply evil or its effects merely negative, it would be possible to confront its threat directly. But like a drug that can cure as well as poison, the *pharmakon* is too slippery to be easily classified, controlled, or contained. Reading Plato against the grain, Derrida argues:

> If the *pharmakon* is "ambivalent," it is because it constitutes the medium in which opposites are opposed, the movement and the play that link them among themselves, reverses them or makes one side cross over into the other (soul/body, good/evil, inside/outside, memory/forgetfulness, speech/writing, etc.). . . . The *pharmakon* is the movement, the locus, and the play: (the production of) difference. It is the *différance* of difference. It holds in reserve, in its undecided shadow and vigil, the opposites and the differends that the process of discrimination will carve out. Contradictions and pairs of opposites are lifted from the bottom of this diacritical, differing, deferring reserve. . . . The *pharmakon,* without being anything in itself, always exceeds them in constituting their bottomless fund. It keeps itself forever in reserve even though it has no fundamental fundity nor ultimate locality.[4]

From this point of view, what makes the *pharmakon* so dangerous is that it cannot be plotted on a grid of oppositional differences. Rather than the opposite of speech, writing, in the strict sense of the term, is the play of differences that makes the opposition between speech and writing—as well

4. Jacques Derrida, *Dissemination,* trans. Barbara Johnson (Chicago: University of Chicago Press, 1981), pp. 140, 127–28. *Différance* is Derrida's neologism for the margin or border that defines differences whose identity seems secure. I will return to this important term below.

as all other oppositions—possible. This non-oppositional difference is endlessly evasive.

When writing is understood as "the medium in which opposites are opposed, the movement and the play that link them among themselves, reverses them or makes one side cross over into the other," it becomes virtually indistinguishable from the metaphorical process with which Tansey associates painting. Derrida's emphasis on the intersection of writing and painting in the play of Plato's *pharmakon* seems to reinforce the similarity between written words and painted figures. But Tansey detects what he regards as lingering suspicions about painting that run throughout Derrida's writings.

While stressing the close association between writing and painting in Plato's consideration of art, Derrida nevertheless tends to subordinate painting to writing. This claim might seem implausible in light of Derrida's extended consideration of graphic dimensions of painting. In *The Truth in Painting* and *Memoirs of the Blind: The Self-Portrait and Other Ruins,* he subjects painting and drawing to careful analysis and provocative interpretation. But there is something resolutely nonvisual about these works. In *The Truth in Painting,* Derrida uses images of painting with very low production values sparingly and largely for illustrative purposes. More interested in the written word than the visual image, his primary focus is always philosophical and literary texts that are about painting. Instead of writing about painting, he writes about writings about painting. In *Memoirs of the Blind,* there are many more pictures and the quality of the reproductions is considerably higher. But the theme of this study—blindness—is symptomatic of a persistent uneasiness with visual materials.[5] This implicit hierarchy between writing and image in Derrida's texts is not, of course, a straightforward repetition of the onto-theological gesture of subordinating speech to writing.

5. Derrida's use of thematic analysis in *Memoirs of the Blind* is uncharacteristic of most of his writings. Instead of presenting detailed analyses of aspects of works that are usually overlooked or repressed, in this work he more or less tells a story that he illustrates with pictures.

While philosophers and artists who are implicitly or explicitly devoted to the principles of onto-theology privilege speech over writing because the former preserves presence and the latter entails absence, Derrida seems to be suspicious of visual images for attempting to preserve a presence that is absent in writing. Plato, in other words, values presence in speech, while Derrida values its absence in writing. Accordingly, for Plato, images have too little presence, and for Derrida they have too much.

The difference between these two positions reflects differences in the traditions to which Derrida is indebted. Mistrust of images in the West, as I have previously noted, is not only the result of the influence of Platonism but, more importantly, grows out of the Jewish theological tradition. Within this context, the danger of the image is that it can be mistaken for the thing itself and thus lead to idolatry. This criticism of images involves a simplistic understanding of representation that presupposes the possibility of a one-to-one correspondence between thing and image. For the religious believer, the critical issue raised by images is not the philosophical or aesthetic question of representation. The prohibition against the creation and use of images is intended to affirm the transcendent power of God and the inescapable dependence of human beings. The written word, in contrast to the visual image, does not seem to be as mimetic or is not mimetic in the same way. Thus, writing does not appear to entail as many temptations as the visual arts. If Judaism is a religion of the book in which writing becomes excessive, this is in no small measure the result of the banishment of images from the precincts of the temple.[6]

While Derrida's writings are not religious in a traditional sense, his works extend and expand ancient theological debates in important ways. Though implicit from the outset, his religious and theological preoccupations have become increas-

6. For a discussion of the way in which these theological issues are related to twentieth-century painting and architecture, see chap. 3, "Iconoclasm," in my *Disfiguring: Art, Architecture, Religion,* pp. 50–95.

ingly explicit in his recent years.[7] Unlike those who are less sophisticated, Derrida realizes that religion is most interesting where it is least obvious. When reading the texts of Franz Kafka, Walter Benjamin, Paul Celan, James Joyce, and others, Derrida detects subtle echoes of the endless arguments among the rabbis. It is as if certain strands in Western literature were an extended midrash that provides an ongoing critique of the Platonism and Christianity inherent in onto-theology. From this point of view, Derrida's prolonged meditation on writing continues the midrashic tradition.

As one of Freud's most insightful interpreters, Derrida realizes—perhaps more than Freud himself—that theology can never be disentangled from psychology. The issue of idolatry, Derrida insists, is as much psychological as it is theological. The God of Judaism is not only creative and omnipotent but is also extremely *jealous*. God demands absolute devotion from his chosen people. Commenting on Joyce's *Ulysses,* Derrida writes:

> As we find the name fire applied to anger and jealousy (see Job 31:12), we can thus easily reconcile the words of Moses, and legitimately conclude that the two propositions of Moses, God is a fire, and God is jealous, are in meaning identical. Further, as Moses clearly teaches that God is jealous . . . we must evidently infer that Moses held this doctrine himself, or at any rate that he wished to teach it, nor must we refrain because *such a belief seems contrary to reason.*[8]

7. See, e.g., Jacques Derrida, *Circumfession,* trans. Geoffrey Bennington (Chicago: University of Chicago Press, 1993), and *The Gift of Death,* trans. David Wills (Chicago: University of Chicago Press, 1995). For related works, see Mark C. Taylor, *Deconstructing Theology* (New York: Crossroad, 1982); *Erring: A Postmodern A/theology* (Chicago: University of Chicago Press, 1984); *Tears* (Albany: State University of New York Press, 1990); and John D. Caputo, *The Prayers and Tears of Jacques Derrida: Religion without Religion* (Bloomington: Indiana University Press, 1997).

8. Jacques Derrida, "Ulysses Gramophone: Hear Say Yes in Joyce," in *James Joyce: The Augmented Ninth,* ed. Bernard Benstock (Syracuse, NY: Syracuse University Press, 1988), p. 40, n. 1. In the book of Deuteronomy, the jealousy of God is directly related to the prohibition against images:
You shall not make a carved image for yourself nor the likeness

A jealous God authorizes no delegates and sanctions neither representatives nor representations. "The uniqueness and unicity of God," as Peggy Kamuf observes, "must forever prevent His appearance through any kind of substitute, any doubling of the eternal One and the Same. God, who is unique and uniquely the one who is, cannot tolerate a double, a replacement, a representative."[9] Always beyond reason as well as the imagination, the jealous God cannot be figured.

When Derrida shifts his attention from painting to drawing in *Memoirs of the Blind,* he focuses on the themes of unfigurability and invisibility by approaching the visual arts through a study of blindness. Echoing de Man's well-known book, which has exercised so much influence on Tansey, Derrida insists that "the moment of blindness ensures sight." This blindness is what Derrida writes *about*—not only in this book but in every text. "I find myself writing," he explains, "without seeing. Not with my eyes closed, to be sure, but open and disoriented in the night; or else during the day, my eyes fixed on *something else [sur autre chose].*"[10] Like the God who never appears, this *autre chose* on which Derrida (impossibly) fixes his eyes is never present and thus cannot be re-presented. Instead of re-presenting the unpresentable *autre chose,* Derrida argues that drawing, in contrast to painting, traces its ceaseless withdrawal.

> Here is a *first hypothesis:* the drawing is blind, if not the draftsman or draftswoman. As such, and in the moment proper to it, the operation of drawing would have something to do with blindness, would in some way regard blindness [*aveuglement*]. In this *abocular* hypothesis (the word *aveugle* comes from *ab oculus:*

of anything in the heavens above, or on the earth below, or in the waters under the earth.

You shall not bow down to them or worship them; for I, the Lord your God, am a jealous god. [5:8–9]

9. Peggy Kamuf, "Reading between the Blinds," in *A Derrida Reader: Between the Blinds,* ed. Peggy Kamuf (New York: Columbia University Press, 1991), p. xxiii.

10. Derrida, *Memoirs of the Blind,* p. 3.

not from or by but without the eyes), the following remains to be heard and understood: the blind man can be a seer, and sometimes has the vocation of a visionary. Here is the *second hypothesis* then—an eye graft, the grafting of one point of view onto the other: a drawing of the *blind* is a drawing *of* the blind. Double genitive. There is no tautology here, only a destiny of the self-portrait. Every time a draftsman lets himself be fascinated by the blind, every time he makes the blind a *theme* of his drawing, he projects, dreams, or hallucinates a figure of a draftsman, or sometimes, more precisely some draftswoman.[11]

If the blind man is a seer, the vision that brings insight requires blindness. Unless one is fortunate enough to be born with the gift of blindness, it would seem to be necessary to gouge out one's eyes in order to see. If blindness is the price of insight, devotion to the jealous God appears to be impossible apart from the sacrifice of vision. Such sacrifice points to the violence that circulates through the biblical text and into the lives of believers like Derrida.

Memoirs of the Blind is not only about the theme of blindness in the drawings of others. Like the sketches of the artists he studies, Derrida's text is, as its subtitle indicates, a self-portrait. Derrida, it seems, is as jealous as the God to whom he is indebted and devoted. His jealousy is provoked by drawing and the violence it implies.

> For I have always experienced drawing as an infirmity, even worse, as a culpable infirmity, dare I say, an obscure punishment. A double infirmity: to this day I still think that I will never know *either* how to draw *or* how to look at a drawing. . . . By *exposing me,* by *showing me up,* it takes me to task but also makes me bear witness. Whence a sort of passion of drawing, a negative and impotent passion, the jeal-

11. Ibid., p. 2. Elsewhere Derrida underscores the interplay between blindness and jealousy by pointing out that the French word *jalousie* means not only jealousy but also designates a kind of shutter or Venetian blind in English as well as French.

ousy of a drawing in abeyance. And which I see with-
out seeing.[12]

To fathom the depths of this jealousy, it is necessary to un-
derstand certain chapters in the family romance that nour-
ished it.

Derrida had three brothers: two older, René Abraham
and Paul Moses, and one younger, Norbert Pinhas.[13] Paul Mo-
ses died before Derrida's birth and Norbert died at the age
of two, when Derrida was ten years old. The sole surviving
brother, René Abraham, could draw very well. In a remark-
able passage, which deserves to be quoted at length, Derrida
confesses that his brother's ability to draw not only aroused
his jealousy but also kindled a fratricidal desire.

> The experience of this shameful infirmity comes right
> out of a family romance, for which I retain only the
> *trait*, a weapon and a symptom, no doubt, as well as
> a cause: wounded jealousy before an older brother
> whom I admired, as did everybody around him, for
> his talent as a draftsman—and for his eye, in short,
> which has no doubt never ceased to bring out and
> accuse in me, deep down in me, *apart from me*, a frat-
> ricidal desire. His works, I must say in all fraternity,
> were merely *copies:* often portraits done in black pen-
> cil or India ink that reproduced family photographs
> (I remember the portrait of my grandfather after his
> death wearing a cap, with a little goatee and wire-
> rimmed glasses) or pictures reproduced from books
> (I still remember this old rabbi praying; but because
> my own grandfather Moses, though not a rabbi, in-
> carnated for us the religious consciousness, a venera-

12. Ibid., p. 36.

13. Proper names, which are always important in Derrida's writings,
are critical for this family romance. The name of René Abraham suggests
the contending philosophical and religious traditions with which Derrida
constantly wrestles. René is, of course, the first name of Descartes, and
Abraham is the name of the father of faith. Paul Moses' name brings to-
gether the name of the first Christian theologian with the name of the
Jewish patriarch who led his people out of bondage and delivered the Ten
Commandments.

ble righteousness placed him above the priest). I suffered seeing my brother's drawings on permanent display, religiously framed on the walls of every room. I tried my hand at imitating his copies: a pitiable awkwardness confirmed for me the double certainty of having been punished, deprived, cheated, but also, and because of this even, secretly chosen. I had sent to myself, who did not yet exist, the undecipherable message of a convocation. As if, in place of drawing, which the blind man in me had renounced for life, I was called by another *trait,* this graphics of invisible words, this accord of time and voice that is called (the) word—or writing, scripture. A substitution, then, a clandestine exchange: one *trait* for the other, *trait* for *trait.* I am speaking of a calculation as much as a vocation, and the stratagem was almost deliberate, by design. Stratagem, strategy—this meant war. And the fratricidal watchword: *economizing on drawing.* Economizing on visible drawing, on drawing as such, as if I had said to myself: as for me, I will write, I will devote myself to the words that are calling me. And here, you can see very well that I still prefer them; I draw nets of language about drawing, or rather, I weave, using *traits,* lines, staffs, and letters, a tunic of writing wherein to capture the body of drawing, at its very birth, engaged as I am understanding it without artifice.[14]

By indirectly recasting the stories of Moses, who delivered the prohibition against graven images and Abraham, whose devotion to the jealous God led him to the brink of an unthinkable sacrifice, Derrida rewrites religious narratives as a family psychodrama. The struggle he stages centers around the tension between writing and drawing and, by extension, words and images. Derrida's letters harbor a violence that expresses a fratricidal passion. Jealousy of René Abraham's ability to draw is what drives Derrida to write. Derrida writes because he cannot draw; more precisely, his writing *is* his

14. Derrida, *Memoirs of the Blind,* pp. 37–38.

drawing. Tormented by passions he is unable to control, the young Derrida decides that his writing will be no ordinary writing; his words will erase more than his brother's pictures. By drawing "nets of language about drawing . . . wherein to capture the body of drawing," Jacques seeks to take René's place. In this family romance, drawing and writing are matters of life and death. "The body of drawing" is the body of the brother, which must be sacrificed for Derrida to write. Like the ancient religious rituals it repeats, this sacrifice involves a substitution that is a displacement. As writing is to drawing, so Jacques is to René. For writing to replace drawing, therefore, would be tantamount to the younger brother taking the older brother's place. Realizing that such a frontal attack on the favored brother would be self-defeating, Derrida displaces his fratricidal passion by developing an indirect strategy. Rather than simply rejecting René's art, Derrida insists that writing accomplishes the aims of drawing more effectively than drawing itself. When pushed to its limit, drawing displays the paragonal structure of the frame, which, Derrida maintains, is constitutive of writing. If writing is a more effective means to accomplish the ends of drawing, then Derrida's words in effect slay René Abraham's images by erasing his drawings. Following in the footsteps of the father of faith, Derrida believes that when "called by another *trait,*" which "is called (the) word—or writing, scripture," the sacrifice of a son or a brother is justified.

When Tansey read Derrida's confession in *Memoirs of the Blind,* he immediately understood its implications for the problem of representation and the place of painting in deconstruction. In the course of developing his own criticism of modernism, Tansey became convinced that painting bears a striking resemblance to what Derrida describes as the activity of writing.[15] Though deeply indebted to deconstruction's anal-

15. It is important to note that Tansey does not distinguish painting and drawing as sharply as Derrida. Picture making, he insists, involves drawing and painting as well as other techniques. In creating pictures, he mingles painting and drawing to such an extent that they become virtually indistinguishable.

ysis of the metaphysics of presence and critique of structural-
ism, Tansey remained puzzled by what he saw as Derrida's
latent aversion to painting. When Derrida lays bare the theo-
logical background and psychological context of his view of
writing, the reasons for his suspicion of visual figures becomes
considerably clearer but, for Tansey, no more defensible. Der-
rida's confession has the effect of reinforcing Tansey's convic-
tion about the importance of the textual dimensions of his
pictures. In good deconstructive fashion, he turns Derrida's
argument back on itself to create pictures that are undeniably
scriptural.

With this complex background in mind, let us return to
Under Erasure. In ways that are not immediately obvious,
Tansey cuts to the heart of the matter by directly citing one
of Derrida's most influential works. In the upper right corner,
the words "The Violence of the Letter" appear like a com-
mandment dimly carved in stone. By now it should be obvious
that Tansey's choice of this text is quite deliberate. In this
work Derrida for the first time presents an extensive account
of his rereading of writing. By appropriating deconstructive
texts in his art, Tansey attempts to recover the interplay be-
tween writing and painting that Derrida recognizes but re-
presses. In a passage previously noted whose significance now
should be more apparent, Tansey explains:

> The key to this rendering or representational func-
> tion is Jacques Derrida's definition of text as "the
> trace of the absence of a presence," which sounds to
> me like drawing. This trace, when repeated, amounts
> to the construction of a texture. And in this sense
> texture functions as the somewhat forbidden bridge
> between text and picture. Through abrasion text
> can become a geological surface, with smudging it can
> appear like atmospheric depth, with erasure it
> can look like water, with crumpling it can be a rock
> or object rendering, etc. (VR 132)

Though not intended as such, this remark actually serves as
a comment on *Under Erasure*. In this work, Tansey brings
together technique and theme to create figures that are as
densely textured as the questions they raise. Bridging text and

picture through the strategy of erasure, he creates a painting that is, in terms echoing Derrida's description of the trace, "the trace of the absence of a presence." Since Tansey figures by subtracting, something is always missing from his works. Unlike artists who crave presence, he does not try to negate lack but deploys erasure to let absence stand forth in its withdrawal. The layers of the painting produce a play of surfaces in which every revealing is a reveiling. The withdrawal implied by this superficial reveiling is, however, a strange retreat. The absence the painting figures is not the erasure of an antecedent presence but is the trace of what is never present and yet is not absent. Following lines laid down by Derrida, the trace that creates an opening for the work of art is not so much a thing as an event, which takes place by not taking (a) place. The nonplace or dis-placement of the trace is the gap. Neither present nor absent, this gap marks the spacing where presence and absence arise and pass away. Inasmuch as spacing eludes presence and thus is never present, it harbors a temporality that exceeds every narrow present. Spacing, in other words, implies a certain timing. Derrida tries to capture the intersection of time and space in the trace with the double meaning of *différer* as differ (space) and defer (time). In his influential essay *"Différance,"* he explains:

> We know that the verb *différer* (Latin verb *differre*) has two meanings which seem quite distinct. . . . In this sense the Latin *differre* is not simply a translation of the Greek *diapherein*. . . . For the distribution of meaning in the Greek *diapherein* does not comport one of the two motifs of the Latin *differre,* to wit, the action of putting off until later, of taking into account, of taking account of time and of the forces of an operation that implies an economical calculation, a detour, a delay, a reserve, a representation—concepts that I would summarize here in a word I have never used but that could be inscribed in this chain: *temporization. Différer* in this sense is to temporize, to take recourse, consciously or unconsciously, in the temporal and temporizing mediation of a detour that suspends the accomplishment or fulfillment of "desire"

or "will," and equally effects this suspension in a mode that annuls or tempers its own effect. . . . [T]his temporization is also temporalization and spacing, the becoming-time of space and the becoming-space of time.[16]

Since the trace is the becoming-time of space and the becoming-space of time, the gap it inscribes is simultaneously spatial and temporal. Tansey sets for himself the impossible task of painting this gap.

Five points in Derrida's analysis of the trace are particularly important for the space-time of the gap. First, since presence presupposes nonpresence, the present is always incomplete. It is important to stress that the nonpresence of the trace is not an absence that once was or sometime could be present but is a more "primordial" or "originary" absence that can never become present. This impossibility of presence violates the narrow present by exposing it to something it needs and yet cannot contain. Second, since the present is never self-contained, the presence of everything necessarily refers beyond itself to something else or something other—*une autre chose*—which interrupts the circuit of self-referentiality and self-reflexivity. Third, the self-referentiality implicit in both presence and the present renders representation unavoidable. Representation, it turns out, is not a process of re-presentation but is the event of de-presentation. As such, it can *only* occur under erasure. Simultaneously erasing what it allows to appear and allowing to appear what it erases, representation figures what cannot be figured. Fourth, always falling between opposites, the trace is irreducibly interstitial, marginal, and liminal. Never in one place or at one time, the trace remains in suspense. Finally, the nonpresence of the trace is at the same time a nonabsent absence, which forms an unbreakable bond with death. For this reason, the trace is a mark of our mortality that can never be erased.

Under Erasure is one in a remarkable series of paintings that Tansey completed in 1990. The discovery of the graphic potential of texts and the textuality of paintings led to an ex-

16. Derrida, *Margins of Philosophy,* pp. 8–9.

traordinary creative eruption. In addition to *Under Erasure* and *Bridge over the Cartesian Gap,* Tansey completed *Valley of Doubt, J. Baptist Discarding His Clothes in the Wilderness (after Domenico Veneziano), Close Reading, Incursion, "a," Reader, Constructing the Grand Canyon,* and *Derrida Queries de Man* in a single year. In all of these paintings, Tansey creates images from silk-screened texts appropriated from the writings of Derrida and de Man. In every case, the text he uses treats issues related to writing. Following the technique established in *Under Erasure,* Tansey layers texts to create figures of rock formations that are faulted and fissured. In *"a,"* a child of uncertain gender underscores the relation between writing and fissuring by carving a petroglyph in a rock wall streaked with erased lines from *Blindness and Insight.* In the middle of what appears to be the head of a humanoid figure, the child engraves the letter "a." While Derrida notes that the word "writing" derives from the Germanic *writan,* which means to tear or scratch, Tansey stresses that the word "painting" is associated with cutting. The stem of "painting" is *peig,* which means to cut or mark (by incision). Whether written or painted, the letter is always incisive and thus inevitably involves a certain violence. The "a" the child carves in stone is the "a" with which Derrida transforms *différence* into *différance.* Rather than a difference contrasted with other differences, *différance* is the differing that constitutes differences as such. This process of differing and deferring is what Derrida means by the activity of writing. Only a few words are legible in the painting entitled *"a."* In the upper left corner, "forgetting" is dimly visible; just above "forgetting," there is an undecidable trace: "eriority," which could be, among other things, either "interiority" or "exteriority." In the lower left corner, fragments of two lines can be read:

of course "presen

therefore avoid figuration or representation
Finally, as if to accentuate the textuality of the painting, Tansey places a note right beside the foot of the child: "2. ibid. p."

The setting of this painting is also crucial to its meaning.

The wall on which the drawing appears seems to be the side of a cave. A glow from behind the child casts a shadow on the surface where the image is drawn. In the yellow light of this setting, Tansey's painting seems to involve a refiguring of Plato's allegory of the cave. By turning his or her back on the light of reason, this foolish young artist creates a dangerous realm of illusions, which is blind to philosophy's warning to "avoid figuration and representation." If this is Plato's cave, the invading stranger turns it inside out by casting everything in a different light. The "a" the youth traces marks a different "origin of the work of art." To trace this origin, we must enter a different cave.

Other paintings done in 1990 create a sense of textual absorption. In *Close Reading,* an athletic woman attempts to scale a text, which is a sheer cliff. While this rock climber clings to the surface, horseback riders in *Incursion* and a runner in *Reader* actually seem to enter the text of the painting or the painting of the text. As figure fades into text, one surface yields to another. In the most ambitious work in this series, *Constructing the Grand Canyon,* Tansey depicts miners, stonecutters, stonemasons, and manual laborers creating a monumental fissure in the earth out of textual fragments. In the middle of the painting at the base of the canyon, the directors of the operation are assembled under the banner of Yale. With a flag bearing a "Y" fluttering in the breeze, Derrida, Harold Bloom, and Geoffrey Hartman gather beside the frame of a pulley, which looks suspiciously like either an "A" or the outline of a pyramid, to confer about their project.[17] In the distance, Michel Foucault sits in contemplation at the feet of a surveyor. The pose Derrida strikes repeats an image Tansey uses in an earlier painting to which we soon will turn. As texts fold into texts, the earth seems to become a complex of what in a preliminary study Tansey labels "discursive formations." Line upon line, texts form sediments that eventually

17. Derrida repeatedly associates the "A" of *différance* with the shape of a pyramid, which is often a tomb. Thus, what Derrida describes as "the pyramidal silence of the graphic difference between the *e* and the *a*" evokes death.

make up the world. No matter how deep these miners dig, they uncover another layer of text. In this world, it's text all the way down. The density of textual strata makes reading difficult and meaning uncertain. While few of the words in this canyon are legible, just to the left of center it is possible to decipher a commandment we have encountered elsewhere: "avoid figuration."

As texts proliferate and paintings accumulate, the question of meaning once again emerges. Tansey's effort to reintroduce meaning into painting is almost too successful. Since too many meanings can be as baffling as too little meaning, doubt creeps back into his work. This doubt is not new, nor is it merely his own; it is the mark of modernity, which Tansey shares with one of his most important precursors—Paul Cézanne. Though traces of Cézanne's work can be found in many of Tansey's paintings, nowhere are they more evident than in the bluish gray hues of *Valley of Doubt*. This painting is organized around the mountain Cézanne made famous: Mont Sainte-Victoire. Looming in the distance, this sacred site is separated from the viewer by a wide and seemingly hostile valley whose near border is formed by massive fragments of letters from what appears to be discarded printer's type. In the midst of the debris, three diminutive figures, dressed in the military attire Tansey associates with the avant-garde, struggle to catch a glimpse of the distant mountain. The image of Mont Sainte-Victoire and the letters, which have suffered as much violence as they have inflicted, are divided by a valley whose strata are obviously textual but completely unreadable. As Tansey ventures from cave to canyon to valley, the gap he explores widens until it becomes unfathomable.

Valley of Doubt refers indirectly to two important paintings Tansey completed three years earlier: *The Bricoleur's Daughter* and *Mont Sainte-Victoire,* both of which were first shown in 1987 at Documenta 8 in Kassel, Germany. Though finished before Tansey started incorporating texts directly in his paintings, these pictures grow out of his reflection on the debates between structuralism and poststructuralism. The manner in which Tansey frames the issues in these pictures

not only prepares the way for the 1990 works but also antici-
pates questions that eventually lead him to pass beyond post-
structuralism.

The Bricoleur's Daughter pictures a young girl in her fa-
ther's studio, standing on top of a wooden box, leaning over
a counter while shining a flashlight on cans of paintbrushes
in a way that casts an intriguing shadow on the wall. Above
and below the work surface there are cabinets and shelves
crammed full with the tools and supplies of the painter's craft.
Tansey's preliminary studies indicate that he builds the paint-
ing around a 1771 print by Joseph Wright entitled *The Black-
smith's Shop.* Throughout the 1960s and 1970s, Lévi-Strauss's
influential studies made the bricoleur a regular figure in
critical debates. In the opening chapter of *The Savage Mind,*
"The Science of the Concrete," he introduces the bricoleur in
an analysis of the relation between mythic and scientific
thought. Like literary tropes, which are always twisting and
turning, Lévi-Strauss associates the "devious" activity of the
bricoleur with the "extraneous movement" of "straying" or
"swerving."

> In its old sense the verb "bricoler" applied to ball
> games and billiards, to hunting, shooting and riding.
> It was however always used with reference to some
> extraneous movement: a ball rebounding, a dog stray-
> ing or a horse swerving from its direct course to avoid
> an obstacle. And in our own time the "bricoleur" is
> still someone who works with his hands and uses de-
> vious means compared to those of the craftsman. The
> characteristic feature of mythical thought is that it
> expresses itself by means of a heterogeneous reper-
> toire which, even if extensive, is nevertheless limited.
> It has to use this repertoire, however, whatever the
> task at hand, because it has nothing else at its disposal.
> Mythical thought is therefore a kind of intellectual
> "bricolage"—which explains the relation which can
> be perceived between the two.[18]

18. Claude Lévi-Strauss, *The Savage Mind* (Chicago: University of
Chicago Press, 1970), pp. 16–17.

The Platonic vestiges of Lévi-Strauss's argument should be clear. Far from the latter-day philosopher who calls himself a scientist and more lowly than the craftsman, the bricoleur can no more be trusted than poets and painters who do not present ideas directly but traffic in signs, which form "an intermediary between images and concepts." By throwing together, linking, or bridging image and concept, the bricoleur "'speaks' not only *with* things . . . but also through the medium of things."[19] It is precisely in the gap between image and concept that Lévi-Strauss locates the work of art.

> The problem of art has been touched on several times in the foregoing discussion [of the bricoleur], and it is worth showing briefly how, from this point of view, art lies half-way between scientific knowledge and mythical or magical thought. It is common knowledge that the artist is something of a scientist and of a "bricoleur." By his craftsmanship he constructs a material object which is also an object of knowledge.[20]

Summarizing Lévi-Strauss's point, Tansey describes the bricoleur as a "French handyman who has a limited set of tools that he uses to solve any problem, and from his way of thinking and working is . . . somewhere between scientific method and magical method" (AS 26). What is important for Tansey in Lévi-Strauss's account of the bricoleur is the cognitive value associated with his activity.

In *The Bricoleur's Daughter,* Tansey identifies the margin between image and concept as the space of painting. Following Plato, who attempts to uncover eternal forms in the midst of temporal becoming, structuralists seek to identify unchanging forms underlying changing events. The painter, by contrast, constantly struggles to find a mean between oppositional extremes. Lévi-Strauss argues that

> The painter is always midway between design and anecdote, and his genius consists in uniting the internal and the external knowledge, a "being" and a

19. Ibid., p. 18.
20. Ibid., p. 22.

"becoming," in producing with his brush an object which does not exist as such and which he is nevertheless able to create on his canvas. This is a nicely balanced synthesis of one or more artificial and natural structures and one or more natural and social events. The aesthetic emotion is the result of this union between the structural order and the order of events, which is brought about within a thing created by man and also in effect by the observer who discovers the possibility of such a union through the work of art.[21]

Like Hegel, who tries to render every *Vorstellung* a *Begriff,* the structuralist attempts to translate art into science. Mimicking neither the philosopher nor the scientist, the painter always works *between* being and becoming as well as structure and event. For Tansey, unlike Lévi-Strauss, this liminal space is not necessarily a site of union but is a place of perpetual dis-placement.

In developing *The Bricoleur's Daughter,* Tansey draws not only on Lévi-Strauss's *The Savage Mind* but also Plato's allegory of the cave, Jacques Lacan's *Four Fundamental Concepts of Psycho-Analysis* and, most important, Derrida's *Spurs: Nietzsche's Styles.* Tansey's studies for this painting show the ways he uses textual fragments to generate both the ideas and the images in the work. He takes the opening sentence in *Spurs* as a prescription for creating the painting: "From this, Nietzsche's letter, I shall snip out the bits and pieces of an erratic exergue."[22] Tansey's drawings, collages, and photomontages function as exergues. An exergue, in the strict sense of the term, is "a small space usually on the reverse of a coin or metal, below the central design, for any minor inscription, the date, engraver's signature, etc." (*American Heritage Dictionary*). But the etymology of the word suggests additional meanings. "Exergue," which derives from *ex* (out of) and *ergon* (work), resonates with "parergon" (*para,* beside + *ergon,*

21. Ibid., p. 25.

22. Jacques Derrida, *Spurs: Nietzsche's Styles,* trans. Barbara Harlow (Chicago: University of Chicago Press, 1979), p. 35.

work). Always outside the work, the exergue functions like a frame de-fining both the beginning and the end of the work. Derrida's fascination with this liminal mark leads him to begin *Of Grammatology* with a section entitled "Exergue" and to introduce *Dissemination* with a term that could serve as a loose translation of both "exergue" and "parergon": *Hors d'oeuvre*. Since the exergue is never part of the work proper, it is always "erratic" and even errant. By beginning with an exergue clipped from *Spurs,* Tansey remains in the intermediate space that Lévi-Strauss marks but his structuralism cannot comprehend.

In an effort to figure what structuralism cannot figure, Tansey begins once again with grids. The wall of the bricoleur's studio is covered with symmetrical gridlike shelves or cabinets; the floor repeats the grid on the floor in *Judgment of Paris II* and recalls the Carl Andre tiles in *A Short History of Modernist Painting.* The darkness of the work space creates a cavelike atmosphere. In an early study for the painting, the wall to the left of the upper cabinet appears to be a cave. Leaving as little doubt as possible about his intentions, Tansey appends two labels to the drawing:

THE SUN	THE GOOD
The LIGHT and POWER	The OFFSPRING or INFLUENCE
of THE SUN	of THE GOOD
The World of Sight	The World of Mind
and things seen	and of things thought

At the base of the cabinet there are two words joined and separated by a broken line.

------OPINION----------KNOWLEDGE------

In the finished version, the texts are completely erased; the upper right quadrant of the painting depicts a Platonic world governed by the abstract principles of geometry. The cabinet is filled with perfect geometric shapes: spheres, cubes, and pyramids. In addition to these ideal forms, there are implements used by the bricoleur-painter: a few brushes as well as all kinds of instruments used for scraping, scratching, and cutting.

Beneath the work surface a different world appears. Four lines borrowed from Derrida's texts label the lower cabinet:

"*coups* and are *coups*" "the tympan," "*la Notion,*" and "meta-operational lost."[23] "Tympan" is the exergue that frames *Margins of Philosophy*. In this foreword, which is both inside and outside the book, Derrida presents a critique of Hegelian philosophy through an inventive reading of Nietzsche's claim "to philosophize with a hammer." Derrida's argument moves toward an unmarked question instead of a conclusion: "And if the tympanum is a limit, perhaps the issue would be less to displace a *given* determined limit than to work toward the concept of limit and the limit of the concept."[24] It is toward this inconceivable limit that Derrida's thinking always tends and Tansey's painting now is drawn.

In the lower cabinet marked "*coups* . . . tympan," *la Notion* is not an Idea or the Concept because the "meta-operation is lost." Here there are no ideal Platonic forms but only shelves stacked with folded canvases, nets, webs, and veils. These are the anamorphic forms that preoccupy Derrida in *Spurs*.

In the question of style there is always the weight or *examen* of some pointed object. At times this object might be only a quill or a stylus. But it could just as easily be a stiletto, or even a rapier. Such objects might be used in a vicious attack against what philosophy appeals to in the name of matter or matrix, an attack whose thrust could not but leave its mark, could not but inscribe there some imprint or form. But they might also be used as protection against the threat of such an attack, in order to keep it at a dis-

23. In another preliminary study, the last line reads: "meta-operational drugs—lost." I have already noted that Plato's use of *pharmakon* to designate both writing and painting lies at the heart of Derrida's argument in "Plato's Pharmacy." When he lifts this line from Derrida's text, Tansey is obviously thinking about the associations linking writing, painting, drugs, illusions, and hallucinations. See Derrida, *Dissemination,* pp. 61–171.

24. Derrida, *Margins of Philosophy,* pp. xii, xvii. Derrida emphasizes the liminal status of "Tympan" by numbering its pages with Roman numerals. In anticipation of our consideration of *Leonardo's Wheel,* it is important to note that Derrida points out in a paranthetical aside that Vitruvius describes the tympanum as "a hydraulic *wheel.*" In a footnote, Derrida includes an image of Vitruvius's waterwheel as well as "*Lafaye's tympanum*" (pp. xx–xxi).

tance, to repel it—as one bends or recoils before its force, in flight, behind veils and sails.[25]

Les voiles—sails and veils . . . *Les toiles*—sails and canvases. A stylus is, inter alia, a pen, a paintbrush, even an umbrella. This umbrella, which Nietzsche forgets, is what spurs Derrida to write *Éperons* and inspires Tansey to paint *Mont Sainte-Victoire.*[26]

The bricoleur's daughter plays at the boundary of the upper Platonic and lower labyrinthian world of webs and nets. Tansey summarizes the horizon dividing the painting: "Above the table I see the realm of Plato's cave and below it the ambiguous attributes—the spurs, webs, and fabrics—of Derrida's *Spurs*. Plato's tools are above and Derrida's weapons are below" (AS 29). Bridging the worlds of Plato and Derrida, the young girl creates shadowy images by casting a light on cans of paintbrushes that look suspiciously like a Jasper Johns sculpture. As the artist's studio becomes a cave, culture is transformed into nature—or at least the image of it. Following the shadows from right to left, silhouettes of paintbrushes gradually become plants and eventually trees, which begin to bend in a manner reminiscent of Cézanne's *Bathers*. At the far edge of the painting, near the back of the cave, stands a representative of the avant-garde gazing through his binoculars toward the (artificial) light. Along this border, *The Bricoleur's Daughter* reaches its limit and folds into *Mont Sainte-Victoire.*

One of Tansey's most remarkable paintings, *Mont Sainte-Victoire* summarizes what he learned from Derrida's critique of structuralism and suggests what he eventually comes to regard as the shortcomings of deconstruction. He builds this painting around an appropriation and refiguration of two of Cézanne's most famous works: *Monte Sainte-Victoire* (1904–6) and *The Bathers* (1898–1905). In characteristically brilliant

25. Ibid., p. 37.

26. Near the conclusion of *Spurs,* Derrida casts doubt on the elaborate argument he has just unfolded by suggesting that Nietzsche's text might be no more comprehensible than a textual fragment found among his literary remains: "I have forgotten my umbrella."

tones of reddish orange, Tansey depicts a group of men in various states of undress lounging on the shore or wading in the water of a lake. A distant mountain, which gives the painting its title, is perfectly mirrored in the crystal clear water. Though not immediately obvious, Tansey's interest in Cézanne is more than artistic. As I have noted, Derrida borrows the title of *The Truth in Painting* from a letter written by Cézanne. But it is Merleau-Ponty and not Derrida who placed Cézanne's work at the center of philosophical and critical debates in the 1950s and 1960s. In 1948, Merleau-Ponty published an important essay entitled "Cézanne's Doubt." We have already seen that Merleau-Ponty's writings influenced several of Tansey's teachers and contributed directly and indirectly to the work of Minimalists. For these critics and artists, *Phenomenology of Perception* is more important than books like *The Visible and the Invisible* and *Sense and Non-Sense,* which includes "Cézanne's Doubt." While *Phenomenology of Perception* can be read as more or less continuous with the principles of structuralism, the other works anticipate some of poststructuralism's most telling insights.[27]

In "Cézanne's Doubt," Merleau-Ponty considers the perennial question of the relationship between an artist's life and work. The larger issue at stake in his analysis is the problem of freedom and determinism in creative activity. Responding to Jean-Paul Sartre's criticism of Freud, Merleau-Ponty presents a rereading of psychoanalysis in which he attempts to preserve human freedom. In the course of developing his argument, he probes Cézanne's near pathological doubt. Cézanne's legendary doubt was radical; he doubted not only his work but also himself. While it is unclear whether this self-doubt led to or was a result of his artistic work, it is evident that Cézanne's understanding of the goal of art makes doubt unavoidable. "The task before him," Merleau-Ponty explains,

27. Lévi-Strauss goes so far as to dedicate *The Savage Mind* "To the Memory of Maurice Merleau-Ponty." Few critics recognize the important relationship between Merleau-Ponty's work and the writings of poststructuralists. I have considered this issue elsewhere; see my *Altarity* (Chicago: University of Chicago Press, 1987), pp. 61–81.

"was, first, to forget all he had ever learned from science and, second, *through* these sciences to recapture the structure of the landscape as an emerging organism."[28] He wanted to depict matter as it takes on form, the birth of order through spontaneous organization. He makes a basic distinction not between "the senses" and "the understanding" but rather between the spontaneous organization of the things we perceive and the human organization of ideas and sciences. . . . Cézanne never wished to "paint like a savage." He wanted to put intelligence, ideas, sciences, perspective, and tradition back in touch with the world of nature which they must comprehend.[29] Cézanne, in other words, was less interested in representing things as they are than in capturing the event of appearing as such. The instant of "emergence," which seems to involve "the birth of order through spontaneous organization," is "the vibration of appearances, which is the cradle of things." This vibration, oscillation, or alternation cannot be arrested in paint unless painting and its apprehension become events through which order emerges. "It is Cézanne's genius," Merleau-Ponty concludes,

that when the overall composition of the picture is seen globally, perspectival distortions are no longer visible in their own right but rather contribute, as they do in natural vision, to the impression of an emerging order, of an object in the act of appearing, organizing itself before our eyes. . . . If one outlines the shape of an apple with a continuous line, one makes an object of the shape, whereas the contour is rather the ideal limit toward which the sides of the apple recede in depth. Not to indicate any shape would be to deprive the objects of their identity. To trace just a single outline sacrifices depth—that is,

28. Maurice Merleau-Ponty, *Sense and Non-Sense*, trans. Herbert Dreyfus and Patricia Dreyfus (Evanston, IL: Northwestern University Press, 1964), p. 13.
29. Ibid., pp. 13–14.

the dimension in which the thing is presented not as spread out before us but as an inexhaustible reality full of reserves. That is why Cézanne follows the swelling of the object in modulated colors and indicates *several* outlines in blue. Rebounding among these, one's glance captures a shape that emerges from among them all, just as it does in perception.[30] The outline, which marks "an inexhaustible reality full of reserves," is the functional equivalent of the exergue, frame, margin, and limit where appearances appear, order emerges, and forms form. Never appearing as such, this threshold approaches by withdrawing. Since appearance presupposes this disappearance, painting is always incomplete.

Cézanne cannot but doubt himself and his work because it is impossible for art to accomplish the task he sets for it. Cézanne, "in his own words," Merleau-Ponty notes, "wrote in painting what had never yet been painted, and turned it into painting once and for all."[31] Painting, then, would seem to be writing, but not just any writing. When Cézanne claims that painting is writing, he anticipates the interpretation of the relationship between painting and writing that Tansey discerns in Derrida's texts more than a half century later. Just as Cézanne's painting figures "the vibration of appearances, which is the cradle of things," so Derrida's writing, or, more precisely, "arche-writing," inscribes the play of differences, which is the matrix of identity and difference. In *Spurs,* the figure of this unfigurable operation is an umbrella.

Tansey's *Mont Sainte-Victoire* turns on the figure of the umbrella. Following a procedure that by now has become familiar, he organizes this painting according to the structuralist's principle of binary opposition. The central horizontal axis establishes the coordinates of the work. With Mont Sainte-Victoire looming in the distance, the women in Cézanne's *Bathers* are transformed into fourteen men standing either on the shore or in the tranquil water of a lake. Among the bathers, it is possible to identify Jean Baudrillard, Roland Barthes,

30. Ibid., pp. 18, 14–15.
31. Ibid., p. 17.

and Derrida. (In one of Tansey's later works, entitled simply *The Bathers,* Jean-François Lyotard and Jacques Lacan join Barthes and Derrida.)[32] Along the border of *Mont Sainte-Victoire,* the avant-garde soldier we saw in *The Bricoleur's Daughter* stands conversing with his comrades. As we look from left to right, the men gradually disrobe. The dominant bather is Derrida who, striking a pose Tansey repeats three years later in *Constructing the Grand Canyon,* stares directly at the viewer while taking off his clothes. The still water of the lake creates clear reflections. On examination, however, these images become puzzling because they do not reflect the bathers. On the surface of the water, men become women. The longer one ponders this painting, the stranger it appears. Gradually it becomes obvious that the whole picture can be inverted. While working on the painting, Tansey had a small version of it mounted on a pivot that he could easily rotate. When the picture is turned upside down, a remarkable change occurs. Not only do men become women, but the mountain becomes a cave. Cézanne's lofty Mont Sainte-Victoire is transformed into Plato's cave and, of course, vice versa. When things are reversed, the interplay of opposites becomes dizzying: man/woman, clothed/naked, veiled/unveiled, earth/water, light/dark, front/back, outside/inside, surface/depth, convex/concave, mountain/cave. . . . But not everything is doubled: at the left edge of the painting, between lake and land, there is a single umbrella. This appears to be Nietzsche's umbrella, which Tansey borrows from *Spurs.* Forming the border along which opposites emerge, everything turns on this inconspicuous umbrella.

But why an umbrella? Umbrellas are, of course, staples in Surrealism. No one was more intrigued by umbrellas than René Magritte, with whom Tansey is often compared. But Tansey's umbrella is more Derridean than Surrealist. The importance of the umbrella in Derrida's work hinges on the

32. In *The Bathers,* Tansey releases a chain of associations with a verbal-visual pun created by replacing the lake with railroad tracks. "Spur," which is the English translation of *éperon,* is also the German word for railroad tracks.

word itself—*parapluie*. We have already noted the prefix *para-* in "parergon," which Derrida associates with what Cézanne describes as "the truth in painting." The *para-* of "parergon" and "*parapluie*" is, however, even more finely nuanced than we have seen so far. J. Hillis Miller summarizes its layers of meaning:

> "Para" is a double antithetical prefix signifying at once proximity and distance, similarity and difference, interiority and exteriority, something inside a domestic economy and at the same time outside it, something simultaneously this side of a boundary line, threshold, or margin, and also beyond it. . . . A thing in "para," moreover, is not only simultaneously on both sides of the boundary line between inside and out. It is also the boundary itself, the screen which is a permeable membrane connecting inside and outside. It confuses them with one another, allowing the outside in, making the inside out, dividing them and joining them. It also forms an ambiguous transition between one and the other.[33]

Folding and refolding back on itself, the umbrella is "the ambiguous transition between" that traces the "boundary line, threshold, or margin" where forms form and thus order emerges.

Though *Mont Sainte-Victoire* is the first picture in which an umbrella appears, one of the textual fragments from *Spurs* appended to *The Bricoleur's Daughter* anticipates its function in Tansey's work. Along the border of what eventually becomes a cave, Tansey cites Derrida:

> Take, for example the hermaphroditic spur (*éperon*) of a phallus which is modestly enfolded in its veils, an organ which is at once aggressive and apotropaic, threatening and/or threatened. One doesn't just happen onto an unwonted object of this sort in a . . .[34]

33. J. Hillis Miller, "Critic as Host," in *Deconstruction in Context* (New York: Seabury, 1979), p. 219.

34. The placement of the ellipsis seems deliberate. The "a" with which this textual fragment ends without ending suggests both the "a" of Derrida's *différance* and anticipates Tansey's picture entitled *"a."*

While multiple oppositions order *Mont Sainte-Victoire,* the dominant structure of the work is rendered through a traditional depiction of sexual difference: men on top, women on bottom. Between male and female lies the "hermaphroditic" umbrella whose sexuality is ambiguous. This ambiguity is what associates the umbrella with spurs and traces as well as *les voiles* and *les toiles.*

> The English *spur,* the *éperon,* is the "same word" as the German *Spur:* or, in other words, trace, wake, indication, mark. The style-spur, the spurring style, is a long object, an oblong object, a word, which perforates even as it parries. It is the oblongi–foliated point (a spur or a spar) which derives its apotropaic power from the taut, resistant tissues, webs, sails, and veils, which are erected, furled and unfurled around it. But, it must not be forgotten, it is also an umbrella.[35]

When erect, an umbrella is actually both convex and concave. Neither simply masculine nor feminine, the figure of the umbrella is the condition of the possibility of the difference between men and women. In this way, the umbrella exhibits the duplicitous structure that Derrida elsewhere associates with gloves and shoes. "Could it be," he asks in *The Truth in Painting,* "that, like a glove turned inside out, the shoe sometimes has the convex form of the foot (penis), and sometimes the concave form enveloping the foot (vagina)"?[36] This remark is offered in the context of a tangled reading of "The Origin of the Work of Art," where Heidegger develops an interpretation of how art originates through a philosophical analysis of a van Gogh painting of peasant shoes. What intrigues Derrida about both van Gogh's painting and Heidegger's reading of it is the function of the untied laces. The reversibility of gloves and shoes—and by extension umbrellas—suggests the interweaving of inside and outside depicted by the shoelaces. Gloves, shoes, umbrellas, and laces exhibit Derrida's "parergonal structure," which, we have seen, is at

35. Derrida, *Spurs,* p. 41.
36. Derrida, *The Truth in Painting,* p. 267.

work in the frame. Responding to critics of van Gogh's painting, Derrida argues:

> All of you seem too sure of what you call internal description. And the external never remains outside. What's at stake here is a decision about the frame, about what separates the internal from the external, with a border which is itself double in its trait, and joins together what it splits. At stake here are all the interests caught up in the trial of this split. The logic of the *parergon* at work here removes all security in this regard.[37]

When interpreted in terms of this parergonal logic, the umbrella is something like a frame in the middle of the work of art, or even a frame whose middle *is* the work of art.

By insisting that the work of art originates with the work of the frame, Derrida is actually extending the argument Heidegger advances when he maintains that art always takes as its point of departure a "rift [*Riss*—tear, cleft, crevice, fissure, gap]." This rift conforms to the faulty geo-logic we have observed in many of Tansey's paintings. In a seminal text, Heidegger explains the rift in a way that draws together many of the issues probed in Tansey's paintings: rift, fissure, gap, frame, framework, figure, and representation.

> The strife that is brought into the rift and thus set back into the earth and thus fixed in place is *figure, shape, Gestalt.* Createdness of the work means: truth's being fixed in place in the figure. Figure is the structure whose shape the rift composes and submits itself. This composed rift is the fitting or joining of the shining of truth. What is here called figure, *Gestalt,* is always to be thought of in terms of the particular placing *(Stellen)* and framing or framework *(Ge-stell)* as which the work occurs when it sets itself up and sets itself forth.[38]

The rift, tear, fissure, or gap is the origin of the work of art because it is the boundary where forms form. Like Derrida's

37. Ibid., p. 331.
38. Heidegger, *Poetry, Language, Thought,* p. 64.

umbrella, which marks the margin of differences, the "rift-design" or "gap-design" articulates the structure of the work. This fissure is simultaneously opened and crossed by the bridge.

On the right border of *Mont Sainte-Victoire*—at the end of the pivotal shoreline/horizon, directly opposite the umbrella—there is a bridge. It is not clear whether this bridge joins the two halves of the picture or fades before it reaches the near shore. We have, of course, already considered the importance of this figure in *Bridge over the Cartesian Gap* and can also discover bridges in many of Cézanne's paintings, which are important for Tansey. Before turning to another bridge in *Leonardo's Wheel,* it is important to recall that Tansey uses the bridge to figure the medium of painting. Our examination of the role of the frame and umbrella discloses further implications of his use of the image of the bridge. Running from umbrella to bridge, the border of water and earth in *Mont Sainte-Victoire* functions as the slim line or trait—the "/"—which, as Derrida insists, "joins together what it splits." For Heidegger, this trait of the bridge is, in effect, the origin of the work of art: "The bridge swings over the stream 'with ease and power.' It does not just connect banks that are already there. The banks emerge as banks only as the bridge crosses the stream. The bridge designedly causes them to lie across from each other."[39] Heidegger's unexpected point in this text is very important: the opposite banks—near and far shores—do not exist prior to the bridge, but emerge in and through it. "A boundary," Heidegger continues, "is not that at which something stops but, as the Greeks recognized, the boundary is that from which something *begins its presencing.*"[40] As the condition of the possibility of presencing, the boundary marked by the bridge allows the banks to be present but is itself always withdrawing and thus is never present. The bridge, in other words, is the trace of the *re-trait* (retreat or withdrawal) of the *trait* that is the origin of the work of art. This elusive *trait* of the bridge is,

39. Ibid., p. 152.
40. Ibid., p. 154.

according to Derrida, the limit toward which "drawing always signals."

Once this limit is reached, there is nothing more to see, not even black and white, not even figure/form, and this is the *trait,* that is the line itself: which is thus no longer what it is, because from then on it never relates to itself without dividing itself just as soon, the divisibility of the *trait* here interrupting all pure identification. This limit is never presently reached, but drawing always signals towards this inaccessibility, toward the threshold where only the surroundings of the *trait* appear—that which the *trait* spaces by delimiting and which thus does not belong to the *trait. Nothing belongs to the trait,* and, thus, to drawing and to the thought of drawing, not even its own "trace." Nothing even participates in it. The *trait* joins and joins only by separating.[41]

This *trait,* like the bridge that figures it, both joins and separates Tansey and Derrida. Following Derrida, Tansey agrees that the *trait* and its withdrawal are the abyssal horizon toward which not only drawing but also painting is always moving. But differences as slight as they are important remain. Obsessed with the blindness that makes vision possible, Derrida constantly probes what cannot be figured by writing texts that subordinate image to word. From this point of view, the task of art is to represent the impossibility of representation. If this is the end of representation, Tansey concludes, what had appeared to be a promising new beginning turns out to be another dead end. While acknowledging the importance of Derrida's account of the interplay of the visible and the invisible, Tansey pushes representation to its limit in order to create pictures that are productive in ever new ways. If painting is to have a future, he believes, it is necessary not only to learn the lessons of structuralism and poststructuralism but also to find a way to move beyond the impasse to which they lead. Perhaps, Tansey concludes, the trait and the structures it delimits are even more complex than either structuralists or

41. Derrida, *Memoirs of the Blind,* p. 53.

poststructuralists realize. While borrowing extensively from Derrida in criticizing Lévi-Strauss, the horizon he explores in *Mont Sainte-Victoire* exceeds the differences that join and separate their frameworks. Always working at what he describes as "the edge of the plausible," Tansey's horizon is, in Merleau-Ponty's terms, the limit of "emerging order" (AS 25). This boundary is what complexity theorists have recently described as "the edge of chaos."

5 Figuring Complexity

While immersed in the debates between structuralists and poststructuralists, Tansey was also reading intensively in the growing literature about fractal geometry as well as catastrophe, chaos, and complexity theory. The 1987 publication of James Gleick's *Chaos: Making a New Science* introduced the general public to the far-reaching implications of changes taking place in some areas of the natural sciences. Some critical theorists were quick to argue that chaos theory provided a point of contact between science on the one hand, and, on the other, literature and literary theory.[1] The more deeply Tansey probed the scientific and mathematical literature, however, the more he began to suspect important differences between poststructuralism and what eventually became complexity theory.

Through his prolonged engagement with structuralism and poststructuralism, Tansey eventually discovered shortcomings in both points of view. Most troubling to him was the recognition that structuralists as well as their critics had an oversimplified view of the characteristics and functions of structures. By insisting that the metastructure of every structure is binary opposition, they failed to appreciate the rich diversity of the structures and orders surrounding us. Binary opposition, Tansey gradually realized, is only one structure

1. See, e.g., N. Katherine Hayles, ed., *Chaos and Order: Complex Dynamics in Literature and Science* (Chicago: University of Chicago Press, 1991).

among many. With the recognition of the diversity and complexity of structures, other problems with poststructuralism came into sharper focus. By accepting a restricted view of structure, poststructuralism had limited its critical effect. Intentions to the contrary notwithstanding, deconstructive criticism devolved into an eternal repetition of the same gesture. In the final analysis, poststructuralists could do no more than repeatedly attempt to subvert or deconstruct the systems structuralists construct. To move beyond this critical impasse, Tansey concluded, it is necessary to refigure both systems and the margin of difference they exclude in more diverse and complex ways. In the nonlinear dynamics between chaos and order, Tansey glimpsed a different space for the work of art.

Fractal geometry, catastrophe, chaos, and complexity theory might not have had such a decisive impact on Tansey's thinking if his initial investigation of nonlinear dynamics had not coincided with an exhibition where he encountered a Leonardo he had not known. In the spring of 1987, he saw a show entitled "Leonardo da Vinci: Engineer and Architect" at the Montreal Museum of Fine Arts. Much to his surprise, Tansey discovered that Leonardo had wrestled with many of the same problems that were preoccupying himself at the time. While interested in Leonardo's prescient investigation of the movement of fluids, Tansey was particularly intrigued by his study of turbulence. The exhibition and accompanying catalog included remarkable sketches of waves, whirlpools, and eddies as well as detailed drawings of a variety of hydraulic devices that Leonardo had invented. Though the Montreal show did not include any of Leonardo's drawings of clouds and the sky, it is important for our purposes to note that he already realized that the same laws regulate turbulence in both water and air. At one point, Leonardo goes so far as to argue that "In order to give the true science of the movement of birds in the air, it is necessary first to give the science of the winds, and this we shall prove by means of the movements of water."[2]

2. Leonardo da Vinci, quoted in Kenneth Keele, *Leonardo Da Vinci's "Elements of the Science of Man"* (New York: Academic Press, 1983), p. 37.

Still operating within the general framework established by Plato and the Neoplatonists, Leonardo is convinced that nature is grounded in geometric structures and governed by mathematical principles. These presuppositions, however, make it difficult for him to explain fluid dynamics. How, he wonders, do straight lines become curves; how do cubes, spheres, and pyramids become waves, whirlpools, eddies, and clouds?

In a 1505 notebook, Leonardo records his intention to write a work entitled *On the Transformation of One Body into Another without Diminution or Increase of Substance.* "For forty folios," Kenneth Keele notes, "he describes the transformations of cubes into pyramids, spheres into cubes, et cetera. This procedure of geometrical 'transformation' is carried further in *Codex Madrid II* where he applies it to transforming rectilinear figures into curvilinear figures."[3] Leonardo's explanation of the process by which geometric forms change into the dynamic shapes of fluids and gases rests on an ingenious interpretation of relationships among basic geometric forms. Not all structures are equal, he argues, because every shape and form is a variation of the pyramid. This understanding of the function of the pyramid grew out of Leonardo's study of perspective (i.e., the perspectival pyramid of monocular vision) and his designs for mechanical devices like levers, pulleys, screws, and springs. Reviewing the results of his observations and experiments, Leonardo concludes:

> We will be telling the truth by affirming that it is possible to imagine all powers capable of infinite augmentation or diminution. Consequently, all powers are pyramidal because they can grow from nothing to infinite greatness by equal degrees. And by similar degrees, they decrease to infinity by diminution ending in nothing. Therefore nothingness borders on infinity.[4]

3. Ibid., p. 36.
4. Leonardo da Vinci, quoted in ibid., p. 93. It is important to recall Derrida's association of the "A" of *différance* with the structure of the pyramid. See chap. 4, n. 17 above.

Not only are all forms variations of the pyramid, but the relations among different forms are pyramidal. Keele summarizes Leonardo's argument:

> It is quite in character to find Leonardo making geometrical play with the five regular Platonic solid bodies described in Plato's *Timaeus*. His procedure is to cut through the angles in such a way that each section forms the base of a solid pyramid. He puts it like this: "Regular bodies are 5, each angle when cut through reveals the base of a pyramid with as many sides as there are faces of such a pyramid. And as many angled bodies remain as sides. These angles can again be sectioned, and so on. One can proceed to infinity because the continuous quantity can be infinitely divided." Thus Leonardo systematically constructed dual configurations of the Platonic regular solid bodies, analyzing them into pyramidal figures, i.e., tetrahedrons. Since Leonardo found "infinite" pyramids locked within the five regular solids, it is interesting to see him attacking Plato's choice of the cube to represent earth as the primary element.[5]

For Leonardo, then, the pyramid and its law form the structure of structure or the metastructure that constitutes everything. The repetition of the pyramid generates the plurality of forms.

This "pyramidal law," however, is not only the foundation of abstract geometric figures. Leonardo's most suggestive claim in this context is that the repetition of the pyramidal structure transforms rectilinear into curvilinear shapes. He discovers what he calls "pyramidal mutation" in his study of springs. Leonardo describes the spring in terms of the concave/convex structure we have already observed in the umbrella.

> If a straight spring is bent, it is necessary that its convex part becomes rarefied or thinner and its concave part denser or thicker. This mutation is pyramidal, whence it is demonstrated that there will never be

5. Ibid., p. 144.

any change in the middle of the spring. This "pyramidal" nature of stress or strain applies widely, to the weights breaking ropes round pulleys, the bending of iron bars and wooden beams, and even the action of muscles.[6]

With precise drawings and careful calculations, Leonardo attempts to demonstrate exactly how the straight sides of the pyramid become the curved lines of the spring. He dubs pyramids with curved sided "'falcates,' a term relating the curve to that of a falx or scythe."[7] Once again extending the principle he discovers beyond the particular phenomenon under examination, Leonardo suggests that the pyramidal law can explain fluid dynamics. Like springs and screws, whirlpools and eddies are falcates produced by the repetition of countless tiny pyramids. Leonardo realizes that when water becomes turbulent, vortices break down into smaller and smaller vortices. He now infers that these dynamics are the result of the pyramidal law. Every vortex is made up of other vortices, which, in the final analysis, are falcates. In other words, the iteration of a simple geometric structure can generate complex dynamic forms. When understood in this way, Leonardo's pyramidal law is, in effect, a principle of morphogenesis.

The accuracy of Leonardo's conclusion is less interesting than the implications of the principle he defines. His pyramidal law anticipates the basic tenets of fractal geometry developed centuries later by Benoit Mandelbrot. In the opening paragraph of *The Fractal Geometry of Nature*, Mandelbrot rephrases the question Leonardo had asked.

> Why is geometry often described as "cold" and "dry"? One reason lies in its inability to describe the shape of a cloud, a mountain, a coastline, or a tree. Clouds are not spheres, mountains are not cones, coastlines are not circles, and bark is not smooth, nor does light travel in a straight line.
>
> More generally, I claim that many patterns of Nature are so irregular and fragmented that, com-

6. Leonardo da Vinci, quoted in ibid., p. 97.
7. Ibid., p. 144.

pared with *Euclid*—a term used in this work to denote all of standard geometry—Nature exhibits not simply a higher degree but an altogether different level of complexity. The number of distinct scales of length of natural patterns is for all practical purposes infinite.[8]

Mandelbrot sets for himself the ambitious task of developing "the morphology of the 'amorphous.'" Whereas Euclidean geometry and traditional physics regard irregular shapes as aberrations, Mandelbrot is convinced that they display previously unrecognized orders, which are no less regular and even more reasonable than the dry abstractions of mathematical and scientific laws.

Though Mandelbrot's mathematical calculations are considerably more refined, his conclusion is remarkably similar to Leonardo's pyramidal law. Clouds, mountains, coastlines, and, by extension, waves, whirlpools, and eddies are produced by the repetition or iteration of simple structures. Two of the central premises of Mandelbrot's analysis are self-similarity and scaling. When certain basic forms are repeated, self-similar structures emerge with characteristics that appear to be quite different from their constituent elements. In one of Mandelbrot's favorite examples—the Koch snowflake—the structure of an equilateral triangle is repeated to produce extraordinarily intricate and remarkably beautiful shapes, which are as curved and twisted as life itself. Such irregular forms cannot be subjected to uniform standards of measurement but must be calculated according to shifting scales. Once Mandelbrot developed mathematical formulas to describe these shapes, he was able to use computers to generate stunning images. Watching rectilinear forms morph into curvilinear shapes, it is difficult not to believe that living organisms are

8. Benoit Mandelbrot, *The Fractal Geometry of Nature* (New York: W. H. Freeman, 1983), p. C3. Mandelbrot explains the origin of his neologism: "I coined *fractal* from the Latin adjective *fractus*. The corresponding Latin verb *fangere* means 'to break': to create irregular fragments. It is therefore sensible—and how appropriate for our needs!—that, in addition to 'fragmented' (as in *fraction* or *refraction*), *fractus* should also mean 'irregular,' both meanings being preserved in *fragment*" (p. 4).

emerging on the computer screen. As John Briggs explains, "Mandelbrot discovered that by using what are called 'nonlinear' equations, the feedback iteration that produces a fractal can bend straight lines into curves and swirls and make the self-similarity at different scales variously deformed and unpredictable."[9]

At one point in his search for examples of fractal forms, Mandelbrot reproduces Leonardo's *Deluge* but offers only a single sentence of explanation: "This is one of the many drawings in which Leonardo represented water flow as the superposition of many eddies of many diverse sizes."[10] Tansey immediately recognized the importance of the association of fractal geometry with Leonardo's scientific and artistic studies. His interest in fractal geometry is reflected in two paintings completed in the mid-1980s. In the first, *Achilles and the Tortoise,* Zeno of Elea, Albert Einstein, Mitchell Feigenbaum, and Benoit Mandelbrot look on as Princess Diana plants a ceremonial tree. The horizon is dominated by a towering pine tree and the cloud of an ascending rocket. In the distance, some men gaze at a tree through binoculars and others prepare to launch a second rocket. While Mandelbrot lectures Zeno, Feigenbaum, who was one of the pioneers in chaos theory, prepares to unleash a volatile mixture of fluid and gas by popping the cork in a bottle of champagne. In the conversation between Zeno and Mandelbrot, the static world of Parmenides encounters the dynamic world described in chaos theory. In his defense of Parmenidean unity, Zeno develops arguments against precisely the plurality and motion that fascinate Mandelbrot. In his best-known argument, to which Tansey's painting refers, Zeno attempts to defend the position of Parmenides against the criticisms of Pythagoras by proving the impossibility of motion. While Parmenidean monism renders the complexities of spatiality and temporality epiphenomenal, the intricacies of fractal geometry articulate the irregularities of concrete temporal and spatial experience. The

9. John Briggs, *Fractals: The Patterns of Chaos* (New York: Simon and Schuster, 1992), p. 68.

10. Mandelbrot, *Fractal Geometry,* p. C3.

most striking feature of Tansey's picture is the common symmetry displayed by the rocket cloud and pine tree. Less obvious but no less important is the similar shape of the pile of dirt that Princess Diana is forming. Vapor trail, tree, and earth all exhibit the same structure. Motion, it seems, is neither amorphous nor illusory but has a discernible structure that forms the substance of life itself.

The second work, *Coastline Measure,* pictures five men and a woman—who looks suspiciously like the bricoleur's daughter—precariously perched on craggy rocks with waves crashing around them. The men are trying vainly to measure the irregularly curved rocks with surveying instruments, straight sticks, and a taut rope. The painting translates into visual form the title of one of the chapters in *The Fractal Geometry of Nature:* "How Long Is the Coast of Britain?" When Mandelbrot answers his own question with the apparently absurd claim that "the coast is infinitely long," his point is that distance and its measure on land are relative to scale and the degree of detail. Since natural forms are neither smooth nor straight, their measure varies with the scale at which it is taken. Just as the geometric forms of abstract painting and binary grids of structuralism are far removed from the complexities of everyday life, so the straight lines of Euclidean geometry, Tansey's painting suggests, are out of touch with the fragmented and twisted shapes surrounding us. In fractal geometry, Tansey finds an interstitial space more complex and productive than the slim trace and inconspicuous *trait* of Derridean deconstruction.

Tansey stresses that fractals mark the transitional space from one dimension to another. For this reason, fractal geometry might be described as the geometry of "the between." The irregular shapes that Mandelbrot describes cannot be produced by equations with integers but result from the calculation of fractions, which, of course, fall between whole numbers. Tansey is convinced that the move from Euclidean to fractal geometry involves a shift from the verticality of the surface/depth or figure/ground relation to the horizontality of an ungrounded lateral play of surfaces. This change is axiological in more than a geometric sense. Within the Platonic

tradition of the West, surface and depth are not regarded equally; depth, which is the inverted image of height, is consistently privileged over surface both ontologically and epistemologically. Accordingly, infrastructures are always foundational and suprastructures epiphenomenal. When depth is reinscribed in a superficial play of figures formed and deformed along fractal faults, fissures, gaps, and seams, this ancient hierarchy, which has long grounded being and knowledge, collapses. Order seems to give way to chaos in an endless flux of appearances.

In June 1984, Tansey read and heavily annotated an article by James Gleick in the *New York Times Magazine* entitled "Solving the Mathematical Riddle of Chaos." The direction of his thinking at the time is indicated by a reference to Leonardo he scribbled in the margin. In this essay, Gleick reports on his conversation with Cornell physicist Mitchell Feigenbaum, whom he describes as "a midwife for a new scientific discipline that is exploring turbulence and disorder of a kind that a decade ago seemed impenetrable."[11] Tansey's notes give ample evidence of his familiarity with the issues discussed in the article. What catches his attention is the report of Feigenbaum's interest in painting. In a passage that Tansey not only underscores but stresses with the sketch of a chessboard grid, Gleick writes:

> In the last few years, he [Feigenbaum] has begun going to museums to look at how artists handle complicated subjects, especially subjects with interesting texture, like Turner's water, painted with small swirls atop large swirls, and then even smaller swirls atop those. "It's abundantly obvious that one doesn't know the world around us in detail," he says. "What artists have accomplished is realizing that there's only a small amount of stuff that's important, and then seeing what it was. So they can do some of my research for me."[12]

11. James Gleick, "Solving the Mathematical Riddle of Chaos," *New York Times Magazine,* June 10, 1984, p. 31.

12. Ibid., p. 68.

After a valiant effort to translate Feigenbaum's complex vision into terms a layperson can understand, Gleick concludes on an artistic note.

"In a way, art is a theory about the way the world looks to human beings. Somehow the wondrous promise of the earth is that there are things beautiful in it, things wondrous and alluring, and by virtue of your trade you want to understand them." He puts the cigarette down. The smoke rises from the ashtray, first in a thin column and then, in a small gesture to universality, in broken eddies and tendrils that continue swirling upward to the ceiling.[13]

During the ensuing years, Tansey, in effect, does what Feigenbaum thinks artists should be doing: he conducts research in chaos theory and nonlinear dynamic systems. The fruit of these labors does not appear for eight years.

When Gleick publishes the book for which his article on Feigenbaum is a preparatory study, he introduces the difficult subject of chaos by the well-known meteorological phenomenon known as "the butterfly effect." The "butterfly effect" designates a condition in which certain effects seem to be disproportionate to the causes with which they originate. For example, a slight disturbance in the air can send out ripples, which, in some distant location, trigger turbulent activity in the atmosphere. This phenomenon was discovered by Edward Lorenz who, in the early 1960s, studied weather patterns by simulating them in the then new electronic computer. He found that in complex nonlinear systems, infinitesimal changes can reverberate through feedback loops to create unexpected effects. To explain the butterfly effect, Lorenz devised the "Lorenzian Waterwheel," which is made up of a rotating wheel with buckets located at regular intervals. "If the stream of water is slow," Gleick explains, "the top containers never fill fast enough to overcome friction, but if the stream is faster, the weight starts to turn the wheel. The rotation might become continuous. Or if the stream is so fast that the heavy containers swing all the way around the bottom

13. Ibid., p. 68.

and start up the other side, the wheel might slow, stop, and reverse its rotation, turning first one way and then the other." When the data gathered from experiments with the waterwheel were graphed, the results were unexpected. The phenomenon Lorenz discovered eventually became known as a "Lorenzian attractor." An attractor is the final state of motion (or nonmotion) to which a particular system evolves from any of a large class of initial configurations. Prior to Lorenz's findings, physicists thought attractors were either fixed points (i.e., activity at steady state) or limit cycles (i.e., periodic repetition). To account for Lorenz's data, it was necessary to posit a third alternative: strange attractors in which motion is chaotic. When the nonperiodic behavior of a strange attractor is graphed, it yields the apparent contradiction of an infinite number of paths inscribed within a finite space. Figures of the data represent what seems to be both the outline of a butterfly's wings and the symbol for infinity. As the lines of the graph twist and turn, fold and refold, the surfaces they circumscribe proliferate. "What we see at each surface," Lorenz explains, "is really a pair of surfaces so that, where they appear to merge, there are really four surfaces. Continuing this process for another circuit, we see that there are really eight surfaces, etc., and we finally conclude that there is an infinite complex of surfaces, each extremely close to one or the other of two merging surfaces."[14] Fascinated by these strange attractors and complex surfaces, Tansey quickly begins collecting images, which become something like a topological picturebook. In one article, which he finds particularly interesting, "Twists of Space," Tansey highlights the concluding paragraph.

"The common thread throughout this collaborative research has been the use of advanced technology and color techniques to make visible the multidimensional layers of abstract information," writes Cox in an article to appear in *Leonardo*. "Supercomputers, graphics, and creative human beings have the power

14. James Gleick, *Chaos: Making a New Science* (New York: Viking, 1987), p. 141.

to bring about visual enlightenment with regard to much in this universe that was formerly abstruse mathematics."[15]

Though Leonardo obviously refers to a journal, the associations it unleashes in Tansey's imagination extend far beyond words on a printed page. Convinced of the revolutionary importance of the new mathematics and physics, Tansey attempts to find ways to "bring about visual enlightenment" through painting.

The appearance of Gleick's book on chaos at the same time as the exhibition of Leonardo's work as an engineer and architect was one of those odd coincidences that so often prove productive. What Tansey found most impressive in the Montreal show were Leonardo's remarkable drawings of turbulent water and inventive designs for waterwheels. Studying Leonardo's plans for elaborate hydraulic devices, his mind quickly wandered to Gleick's discussion of the Lorenzian Waterwheel. Five years later, this conjunction results in one of his most important paintings. *Leonardo's Wheel* took more than a decade to conceive but only two days to paint. It is a picture as complex as the ideas it represents. In this painting, fractal geometry and chaos theory come together in wheels and whirlpools conceived by Leonardo to depict a world where endless doubt and incessant criticism give way to an appreciation for the creative resources of complex dynamic systems.

Leonardo's Wheel simultaneously repeats and subverts many of the strategies Tansey uses in earlier paintings. Near the center of the painting, there is a large waterwheel reminiscent of Tansey's Color Wheel whose spinning generates works of art. The greenish blue monochrome favored by Tansey approximates a grid structured by horizontal and vertical axes that divide the canvas into four quadrants. In contrast to paintings like *A Short History of Modernist Painting* and *Iconograph I,* the axes in *Leonardo's Wheel* are broken, fissured, dislocated. As straight lines break, they create the slippage (where) Tansey paints. The dominant images in the

15. Ivars Peterson, "Twists of Space," *Science News* 12 (October 24, 1987): 266.

picture—the waterwheel and the arches supporting it—are borrowed from drawings by Leonardo, which also appeared in the exhibition and its catalog.

The left half of the painting is bisected horizontally by the image of a bridge similar to the one in *Mont Sainte-Victoire*. Traces of this earlier work can also be detected in the apparent reversibility of the upper and lower left quadrants. Still waters create perfect reflections of cumulus clouds and round off the semicircles of the bridge's arches. But in this case, the appearance of reversibility is an illusion. At the edge of the bridge, a man leans over and tosses a stone into the quiet water. Spreading ripples interrupt the seemingly closed circuit of reflection. The vertical axis is defined by the waterwheel and a bridgelike dam dividing the calm of the lake from the turbulence of a cataract. In contrast to the tranquillity on the left, the right side of the painting pictures ominous clouds and raging waters rushing through cleft rocks into a seemingly fathomless abyss. At the brink of the dam, two boys sit facing in opposite directions. While one disturbs the serenity of the lake by sticking his toes in the water, the other creates a waterfall within a waterfall by dangling his feet over the edge. A sense of time's passage pervades the work. Arches in a state of partial ruin threaten to buckle, leaving the waterwheel to collapse and be washed away in the roaring torrent. It is as if the turning of the wheel records the entropy enveloping everything. The most important points in *Leonardo's Wheel* are the zones of transition. In this painting, everything occurs in the complex space *between* order and chaos.

Tansey approaches chaos and complexity by way of catastrophe theory. While theories of catastrophe, chaos, and complexity are closely related and not always clearly distinguished, they differ in important ways. Most of what Tansey knows about catastrophe theory he learned from a book given him in 1984 by Monte Davis and entitled simply *Catastrophe Theory*. The authors, Davis and Alexander Woodcock, who at the time was a professor of biology at Williams College, begin their book by explaining that "catastrophe theory is a controversial way of thinking about change—change in a course of events, change in an object's shape, change in a sys-

tem's behavior, change in ideas themselves. Its name suggests disaster, and indeed the theory can be applied to literal catastrophes such as the collapse of a bridge or the downfall of an empire. But it also deals with changes as quiet as the dancing of sunlight on the bottom of a pool of water and as subtle as the transition from waking to sleeping." As this remark suggests, catastrophe theory is designed to explain social and cultural as well as natural phenomena. What makes this new approach controversial is its suggestion that "the mathematics underlying three hundred years of science, though powerful and successful, have encouraged a one-sided view of change."[16] Principles long favored by mathematicians and physicists tend to characterize change as quantitative and continuous. When such change is plotted, it yields charts and graphs whose lines are smooth and unbroken. If discontinuities and so-called irregularities happen to be observed, they are interpreted as aberrations or distortions.

Catastrophe theorists, by contrast, are persuaded that "discontinuity is as much the rule as the exception." Accordingly, they are interested in abrupt, qualitative changes resulting in sudden dislocations and disruptions. The central ideas of catastrophe theory can be traced to pioneering work done in the 1950s and 1960s by the French mathematician René Thom. Thom is convinced that Euclidean geometry and the axioms of classical mathematics and physics defined by Newton are ill-suited to describe a world governed by Heisenberg's uncertainty principle and quantum mechanics. The apparently pristine world of Newtonian physics, he believes, is as distant from the complexity of the world and life in it as a Mondrian grid is from the tangled branches and roots of a tree.[17] Thom prefaces his remarkably wide-ranging book,

16. Alexander Woodcock and Monte Davis, *Catastrophe Theory* (New York: Avon Books, 1978), p. 1.

17. It is not clear whether Newtonian mechanics are as incompatible with the principles of catastrophe theory as Thom insists. While Newton might not have investigated complex systems, there is no reason the physics he developed cannot be used to describe them. In this context, the details of the debate between Thom and Newton are less important than the significance Tansey sees in the distinction between linear and nonlinear systems.

Structural Morphology and Morphogenesis, with a simulated image of a pyramid, which appeared in a slide show called "Fossils of the Cyborg: From the Ancient to the Future," and an accompanying epigram from D'Arcy Thompson's *On Growth and Form:* "The waves of the sea, the little ripples on the shore, the sweeping curve of the sandy bay between the headlands, the outline of the hills, the shape of the clouds, all these are so many riddles of form, so many problems of morphology."[18] As this exergue suggests, Thom is interested in many of the phenomena that Mandelbrot explores in his fractal geometry. However, Thom is intrigued not only by irregular structures but also by the way in which these forms change. Immediately after quoting Thompson, he begins his argument by observing that:

> One of the central problems studied by mankind is the problem of the succession of form. Whatever is the ultimate nature of reality (assuming that this expression has meaning), it is indisputable that our universe is not chaos. . . . We must conclude that the universe we see is a ceaseless creation, evolution, and destruction of forms and that the purpose of science is to foresee this change of form and, if possible, explain it.[19]

In the following chapters, Thom examines morphogenesis in a broad range of natural, social, and cultural phenomena. When Tansey encounters these ideas, as summarized by Woodcock and Davis, the issue that most interests him once again is time. With the help of Thom, Tansey realizes that classical mathematics and linear systems are plagued by many of the same problems he sees in Platonism, structuralism, and abstract art. In the margin of a heavily underlined passage from *Catastrophe Theory,* he notes "Topology vs. Geometry." "What kind of mathematics does Thom offer instead?" Woodcock and Davis ask. "The answer," they suggest,

18. René Thom, *Structural Stability and Morphogenesis: An Outline of a General Theory,* trans. D. H. Flower (Reading, MA: Addison-Wesley, 1972), p. 1.

19. Ibid., p. 1.

is topology, a sophisticated descendant of geometry. Instead of the straight lines, restricted curves, and regular solids of Greek geometry, topology deals with all conceivable forms, abstract and multi-dimensional forms as well as those that can be drawn. Thom is an acknowledged master of differential topology, a specialized field which combines these forms with elements from calculus in order to deal with questions of stability and transformation. Greek geometry was essentially timeless: any triangle or circle in the real world was considered an imperfect, changeable "shadow" of the ideal, eternal, mathematical form. Thom uses differential topology to start from the opposite premise: that changes of form in processes as well as objects are real, and that the aim of science is to grasp what he calls the universe's "ceaseless creation, evolution and destruction of forms."[20]

If change is not continuous, development is punctuated by gaps and fissures. While incalculable in terms of classical mathematics, Thom insists that these sites of transition are nonetheless comprehensible. Even though shifts between stable and unstable conditions are discontinuous, they occur in surprisingly stable ways. One of the primary aims of Thom's analysis is to develop a typology of catastrophic change.

In a manner reminiscent of William Empson's *Seven Types of Ambiguity,* Thom identifies seven types of catastrophe, which he describes as "singularities." In topology, singularities are "phenomena that occur when the points of one surface are projected onto another as the surfaces are topologically distorted," and in calculus, the term designates "a point on a graphic curve where the direction or quality of curvature changes."[21] Thom's use of "singularity" appropriates both of these meanings to specify sites of discontinuous phase transition. After lengthy mathematical analyses, he concludes that all catastrophic changes can be classified under seven headings: fold, cusp, swallowtail, butterfly, parabolic, hyperbolic,

20. Woodcock and Davis, *Catastrophe Theory,* p. 7.
21. Ibid., pp. 16–17.

and umbilic. These categories describe the visual features of the graphs that model different changes.

If one examines *Leonardo's Wheel* with Thom's analysis in mind, it quickly becomes clear that there are traces of all seven catastrophes in the painting. Thom often describes his work as an extended effort to develop an "art of models" capable of "generating and classifying analogies both within and across disciplines."[22] The very axes organizing *Leonardo's Wheel* suggest the principles Thom defines. As I have noted, the horizontal and vertical axes are broken, fragmented, and dislocated. Neither line is continuous; both appear to have split and slipped. Furthermore, the vertical line that draws the eye into the picture along the edge of the dam represents the cusp of order and disorder. The example Woodcock and Davis cite to illustrate Thom's general notion of catastrophe could serve as a description of Tansey's painting: "The catastrophe is the 'jump' from one state or pathway to another. In the landscape imagined by Waddington, it could be represented as a passage of an object from one basin to another, or as a flow of water from one channel into another."[23] But Tansey does not leave the reader/viewer to draw conclusions without providing clues to his strategy. The man who throws a stone into the still water leans over the edge of the bridge at the precise point that the horizontal axis shifts. Woodcock and Davis preface a chapter entitled "Applications in Physics, Chemistry and Biology" with a quotation from Thom: "If you want to know what happens when you throw a stone into a pond, it is infinitely better to make a trial and film it than to attempt to theorize about it; the best specialists [in fluid dynamics] would certainly be unable to tell you more about it."[24] For Tansey, of course, the preferred medium is paint rather than film. But the inquiry he conducts in *Leonardo's Wheel* takes up Thom's challenge. If, as Thom insists, "we can see much more than we can say," then, perhaps, our investigative descriptions should be visual rather than only verbal.

22. Ibid., p. 28.
23. Ibid., p. 32.
24. Ibid., p. 76.

Tansey's mind is, however, as restless as the clouds and water he paints. The more carefully he considers catastrophe theory, the more he begins to suspect that in spite of Thom's intentions to the contrary, his criticism of classical mathematics and science is still haunted by the specter of Platonism. While claiming to shift focus from eternal forms to temporal change, Thom remains preoccupied with establishing a morphology of morphogenesis. He is, in other words, more concerned with structures than events. When placed within a broad historical perspective, Thom's seven types of catastrophe appear to be the latest version of Platonic archetypes. Tansey's suspicions are confirmed when he reads Woodcock and Davis's account of Thom's response to E. Christopher Zeeman's topological knot theory: "In Zeeman's ideas, and to some extent in those of contemporary thinkers such as structuralist Lévi-Strauss and Noam Chomsky, who were transforming anthropology and linguistics, Thom found corroboration for his growing belief that thought and language are shaped by deep principles of structural stability just as surely as physical processes."[25] If catastrophe theory concludes by discovering "deep principles of structural stability," it reverts to precisely the kind of atemporal foundationalism Tansey is struggling to overcome.

Tansey is not alone in his misgivings about catastrophe theory. In the years following Thom's most important work, catastrophe theory was taken up into and transformed by chaos theory. Tansey's exploration of chaos theory eventually leads to his study of complexity theory. In the spring of 1996, he spent several weeks at the center for the study of complexity—the Santa Fe Institute.

We have already encountered the rudiments of chaos theory in our brief consideration of Lorenz's butterfly effect. As investigators probed Lorenz's discovery, they began to appreciate the important implications of the difference between linear and dynamic nonlinear systems. In his widely read book, *Order Out of Chaos,* Nobel laureate Ilya Prigogine records the central question to which his investigation is devoted.

25. Ibid., p. 20.

Newton's law [of universal gravitation] provided a means of predicting and manipulating. Nature thus becomes law-abiding, docile, and predictable, instead of being chaotic, unruly, and stochastic. But what is the connection between the mortal, unstable world in which atoms unceasingly combine and separate and the immutable world of dynamics governed by Newton's law, a single mathematical formula corresponding to an eternal truth unfolding toward a tautological future?[26]

Both Prigogine and Tansey respond: "very little." In the idealized world Newton describes, systems are closed and motion, unless disturbed, follows straight lines. Causality involves a predictable relationship in which effects are always proportionate to their causes. Moreover, since such an ideal system is frictionless, time seems to be reversible. Murray Gell-Mann, another Nobel laureate and a founder of the Santa Fe Institute, explains some of the implications of quantum mechanics for Euclidean geometry and Newtonian physics. In his *The Quark and the Jaguar,* a book Tansey knows and admires, Gell-Mann writes,

If classical deterministic physics were exactly correct, the positions and momenta of all particles in the universe could be specified exactly at any given time. Classical dynamics could then, in principle, predict with certainty the positions and momenta of all the particles at future times. (The phenomenon of chaos produces situations in which the slightest imprecision in initial positions or momenta can lead to arbitrarily large uncertainties in future predictions, but in classical theory perfect determinism would still be correct in principle, given perfect information).[27]

In the "real world," however, perfect information is never attainable. Though there are many reasons for this impossibil-

26. Ilya Prigogine, *Order out of Chaos: Man's New Dialogue with Nature* (New York: Bantam Books, 1984), p. 63.

27. Murray Gell-Mann, *The Quark and the Jaguar: Adventures in the Simple and the Complex* (New York: W. H. Freeman, 1994), p. 143.

ity, two are noteworthy in this context. First, finite systems are never closed but are always open; and, second, some systems are complex and nonlinear and thus cannot be understood in terms of the classical linear model of causality. In open, nonlinear dynamic systems, initial conditions cannot be measured with enough precision to determine causal relations accurately beyond a limited period of time. Unpredictability is, therefore, unavoidable. Unlike linear systems in which causes and effects are proportional, in nonlinear systems, causes can have disproportional effects. The nonlinearity of the system can create positive feedback loops, which repeatedly fold back on themselves to amplify effects until they far exceed the causes occasioning them. When the nonlinear system is complex, parts interrelate in such a way that the system can function as a whole without impeding the activity of its separate parts. This complex sense of the whole is one of the things that Tansey correctly sees as missing in both poststructuralism's critique of structuralism and catastrophe theory's revision of classical mathematics and science.

Though appreciative of certain aspects of chaos theory, Tansey is not completely satisfied with it. In a certain sense, chaos theory is not chaotic enough. Just as catastrophe theory discovers permanent structures in changing forms, so chaos theory identifies nonrandom operations at work in apparently random processes. Chaos is, in effect, a state of "deterministic randomness." While deterministic rules govern individual components of a system on the microscopic level, prediction at the macroscopic level is impossible due to our inability to ascertain all relevant initial conditions. Systems, therefore, are practically but not inherently unpredictable. In such systems, Tansey asks, can there be space and time for chance?

Ever since he painted *Mont Sainte-Victoire,* Tansey has been preoccupied with what Merleau-Ponty, commenting on Cézanne, describes as "emerging order." As he stretches and twists the margin of difference joining and separating opposites, the space and time of transition between chaos and order become increasingly complex. If chaos theory differs from catastrophe theory by stressing dynamics more than structures, complexity theory differs from chaos theory in its investiga-

tion of "the edge of chaos" rather than chaos as such. As a leading complexity theorist, Stuart Kauffman, maintains, "The region between order and chaos gives rise to the most complex dynamics."[28] Neither totally ordered nor completely chaotic, life is always in a state of emergence under conditions that are "far from equilibrium." Like catastrophe and chaos theorists, complexity theorists examine discontinuous change in nonlinear dynamic systems. But they are less concerned with the morphology of morphogenesis and the nonrandomness in ostensibly random behavior than they are in the diversity and adaptivity of complex systems. The structural diversity articulated in complexity theory, Tansey believes, provides alternative models for structures and systems that overcome many of the problems he detects in both structuralism and poststructuralism. By addressing the difficulties in catastrophe and chaos theory, complexity theory constitutes a third alternative *between* structuralism, in which fixed universal structures exclude time and repress specific differences, and poststructuralism, in which the criticism of the purportedly totalizing propensities of all systems leads to a valorization of differences that share nothing in common.

Exploring the domain between order and chaos, complexity theorists attempt to describe how systems, structures, and forms emerge. Accepting many of the criticisms of classical mathematics and traditional physics developed in catastrophe and chaos theory, complexity theory is designed to explain systems that are open, dynamic, and nonlinear. Unlike the hermetic world of Euclidean geometry and Newtonian physics in which change is unreal and time is reversible, the openness of dynamic systems allows for the possibility of interactions in which energy is exchanged. In accordance with the second law of thermodynamics, this exchange inevitably results in entropy, which, in the long run, leads to the breakdown of the system. This is an important point for Tansey. As we have seen, one of the reasons he is so resistant to the notion of structure that dominates the West from Plato to

28. Stuart Kauffman, *The Origins of Order: Self-Organization and Selection in Evolution* (New York: Oxford University Press, 1993), p. 232.

Lévi-Strauss is that supposedly permanent structures ultimately negate temporal processes. If, however, structures are entropic, they are irreducibly temporal. In a complex dynamic world, time can no more be escaped than it can be reversed.[29]

When order emerges from the chaos of entropy, it follows the principle of "self-organized criticality." To illustrate this idea, Kauffman borrows an example from Per Bak that is reminiscent of the Lorenzian waterwheel. In this case, it is a question of sand rather than water, but the operative principle is the same. Consider a pile of sand on a table to which grains are slowly added:

> As the sand piles up, it begins to slide off the edges of the table. Eventually, the system reaches a steady state at which the mean rate of dropping sand onto the pile equals the mean rate at which sand falls over the edges. At this stage, the slopes from the peak of the edges of the table are near the rest angle for sand. Bak asks the following question: if one adds a single grain of sand to the pile at a random location and thereby starts an avalanche, what will the distribution of the avalanche sizes be? He finds a characteristic power-law distribution relating the frequencies and sizes of avalanches, with many tiny avalanches and a few larger ones. He argues that this distribution is characteristic of a wide range of phenomena, including distribution of earthquake sizes and other examples. The argument requires that the system under investigation attain and maintain a kind of poised state able to propagate perturbations—avalanches—on all possible length or size scales.[30]

This example sheds considerable light on phase transitions. Dynamic systems are never completely stable but are characterized by "punctuated equilibrium." Once a system reaches a certain critical point, it is on the edge of chaos. The collapse

29. The emergence of organized structures can, however, temporarily delay but not finally overcome entropy.

30. Kauffman, *The Origins of Order,* p. 255.

and reorganization of the system results from the intersection of the aleatory and the necessary in an event that is neither inside nor outside structure as such. When the critical grain of sand is added, processes are triggered that result in the reorganization of the system and the emergence of new patterns of order. Here, as in chaos theory, the nonlinearity of systems creates positive feedback called an "amplifier effect," which leads to effects disproportionate to their causes. These effects grow out of the actions and interactions of subsystems distributed throughout the larger system. Like whirlpools and eddies that eventually cascade into a cataract, the "tiny avalanches and a few larger ones" finally trigger the avalanche "as a whole."

Several important aspects of this process must be noted. First, as the example of the avalanche suggests, complex, dynamic, nonlinear systems are decentered or distributed. Instead of hierarchical structures governed by centralized control, complex systems are distributed networks whose activity is generated by myriad parallel processes. Second, and correlatively, complex systems are not subject to a single law, rule, or principle that regulates the whole. Consequently, emerging order is not prescribed or programmed. Arising from nonlinear interrelations among subsystems within subsystems, self-organization is contingent. This contingency renders morphogenesis irreversible and the structures it generates temporal. Third, since complex systems are systems of systems or networks of networks, they are necessarily adaptive. As the complexity of systems increases, the strategies of adaptation become more intricate. Structures as different as interpretive frameworks, computer programs, biological organisms, and socioeconomic systems can be understood as complex adaptive systems. Computer scientist John Holland, who created the important field of genetic algorithms, describes the shared features of complex adaptive systems (CAS):

> Even a brief inspection reveals some characteristics common to all CAS: All CAS consist of large numbers of components, *agents,* that incessantly interact with each other. In all CAS it is the concerted behavior of these agents, the *aggregate behavior,* that we

must understand, be it an economy's aggregate productivity or the immune system's aggregate ability to distinguish antigen from self. In all CAS, the interactions that generate this aggregate behavior are nonlinear, so that the aggregate behavior cannot be derived by simply summing up the behaviors of isolated agents. . . .

Another feature comes close to being a trademark of CAS: The agents in CAS are not only numerous, they are also diverse. An ecosystem can contain millions of species melded into a complex web of interactions. The mammalian brain consists of a panoply of neuron morphologies organized into an elaborate hierarchy of modules and interconnections. This diversity is not just a kaleidoscope of accidental patterns. The persistence of any given part (agent) depends directly on the context provided by the rest. Remove one of the agent types and the system reorganizes itself with a cascade of changes. . . . Moreover, the diversity evolves, with new niches for interaction emerging, and new kinds of agents filling them. As a result, the aggregate behavior, instead of settling down, exhibits a perpetual novelty, an aspect that bodes ill for standard mathematical approaches.[31]

In addition to suggesting the remarkable phenomena that can be understood as complex adaptive systems, Holland's summary underscores one of their characteristics that is most important for Tansey. Within complex webs of interaction, laws are local rather than universal. There is neither a law of laws nor an overarching metastructure; to the contrary, there is only the interplay of laws, which are always context-specific. The local and the global are inextricably interrelated in such a way that each is a function of the other. Instead of a universal principle or law dominating the system, global activity is

31. John Holland, "Echoing Emergence: Objectives, Rough Definitions, and Speculations for ECHO-Class Models," in *Complexity: Metaphors, Models, and Reality,* ed. George Cowan, David Pines, David Meltzer (Reading, MA: Addison-Wesley, 1994), pp. 310–11.

nothing more and nothing less than the ceaseless interaction of local networks.

By stretching and twisting the space of transition between order and chaos, Tansey discovers structures more diverse and complex than either structuralists or poststructuralists ever imagine. Convinced that life is always lived at the edge of chaos, he finds in complexity theory new resources for painting. While his effort to figure complexity already begins in *Leonardo's Wheel*, it reaches maturity in a picture finished two years later—*Water Lilies.*

As the title of this work indicates, Tansey once again takes as his point of departure the work of one of the icons of modernism: Claude Monet. Tansey's *Water Lilies* is a massive diptych measuring overall 56 inches by 196 inches. Images of bare trees and billowing clouds are reflected in a pond where lily pads are surrounded by melting ice and swirling water from a rushing river overflowing its banks. The size, as well as the title and subject, recalls Monet's overwhelming canvases. Along the upper border, near the center of the work, Tansey turns Monet on his head by depicting his reflection as he bends over to turn a wheel, which appears to open the floodgates and release a deluge that threatens to destroy his work. Monet, of course, was obsessed with water lilies. Having built an artificial pond following Japanese models in the garden of his home in Giverny, he began painting water lilies in 1897 and did not stop until his death in 1926. In these works, Monet extends the practice of serial painting begun in his famous renderings of haystacks and the Rouen cathedral. What most fascinates Monet is not so much the object as our apprehension of it in the flickering play of light. In his water lily paintings, he turns away from the thing itself and toward its reflection on the surface of a pond. While intended to capture the instant of experience in the presence of paint, an inescapable absence haunts these works. In this way, there is, as Robert Hughes suggests, a certain similarity between Monet's paintings and Mallarmé's poems.

Monet's *Water Lilies* are close to the ideas of his contemporary, the poet Stéphane Mallarmé, on poetry. In these paintings, emptiness matters as much as full-

ness, and reflections have the weight of things. Mallarmé conceived of poetry as being a structure of words *and* absences: . . . "To conjure up the negated object, with the help of allusive and always indirect words, which constantly efface themselves in a complementary silence, involves an undertaking which comes close to the act of creation."[32]

Though tracing emptiness and absence, the purpose of Monet's act of creation seems less to disturb and disrupt than to calm and relax. "The pond," which is artificial rather than natural, Hughes continues, "was a slice of infinity. To seize the indefinite; to fix what is unstable; to give form and location to sights so evanescent and complex that they could hardly be named—these were basic ambitions of modernism."[33]

And yet, for all the evanescence and complexity of Monet's *Water Lilies,* an undeniable calm pervades his work. Reflecting on his paintings in 1909, Monet remarks:

At one point I was visited by the temptation to use the theme of *nymphéas* for a decoration. Carried the length of the walls, enveloping the entire interior with its unity, it would attain the illusion of a whole without end, of a watery surface without horizon and without banks; nerves overstrained by work would be relaxed there, following the restful example of the still waters, and to whomsoever lived there, it would offer an asylum of peaceful meditation at the center of a flowery aquarium.[34]

The surface of *Water Lilies* reflects the surface of the pond where opposites mingle in a turbulent play while remaining strangely peaceful. Writing in 1929, Monet's friend Georges Clemenceau detects in this paradoxical flux something approaching Brownian motion.

All the radiating energies of sky and earth are here simultaneously conjured up before us, the ineffable

32. Hughes, *The Shock of the New,* pp. 121–24.
33. Ibid., p. 124.
34. Monet, quoted in Charles F. Stuckey, *Monet: Water Lilies* (New York: Hugh Lauter Levin Associates, 1988), p. 18.

astonishment of a scene that mingles the joys of dreaming with the freshness of primordial sensation. A breath of Infinity sustained by the most delicate sensations of tangible reality and fusing, from reflection to reflection, with every supreme nuance of the imperceptible: this is the theme of the panels. It takes the miracle of a retina formed for this purpose by evolution itself—and the miracle of a painter who can capture the very elements of light and the shades of color. . . . Are we not thus close to a visual representation of Brownian motion? Certainly the gap between science and art is bridged here.[35]

What Clemenceau could not know is that the Brownian motion he sees in Monet's painting prefigures what eventually comes to be known as chaos theory.[36]

It is precisely the dynamic interplay of opposites at work in *Water Lilies* that draws Tansey to Monet's painting. Having learned from complexity theorists that life inevitably emerges in conditions far from equilibrium at the edge of chaos, Tansey detects in Monet's shifting clouds and rippling pond anticipations of a universe that has become considerably more turbulent.

As in *Leonardo's Wheel,* rushing water and fleeting clouds create a sense of movement and dynamism. But Tansey's two works differ in important ways; while their colors are the same, their structures are different. In *Water Lilies,* the grid-like design characteristic of so many of Tansey's works is replaced by an extended horizontal filmlike surface that seems to go on forever. This painting appears to be miles wide and an inch deep. The rigid linearity of hierarchy gives way to a

35. Georges Clemenceau, "Claude Monet," in *Monet: A Retrospective,* ed. Charles F. Stuckey (New York: Park Lane, 1985), p. 355.

36. For an explanation of the relation between Brownian motion and chaos theory, see Ivar Ekeland, *Mathematics and the Unexpected* (Chicago: University of Chicago Press, 1988), p. 40; and *The Broken Dice, and Other Mathematical Tales of Chance* (Chicago: University of Chicago Press, 1993), pp. 160–64. I would like to express my sincere appreciation to my colleague William Wootters for helping me make my way through the tangled terrain of catastrophe, chaos, and complexity theory.

lateral dispersal of dynamic nonlinear patterns. The painting creates a rush both on its surface and in the viewer. Gone is the atmospheric quality of Monet's impressionistic brushwork and in its place are images whose resolution makes them appear hyperreal.

Whereas Monet erases borders and banks, Tansey creates a vertiginous play of margins that leaves everything edgy. There is only one straight line in the painting and it is broken. A small wooden barrier cuts across the upper right corner to form a triangle that resembles the side of a pyramid. The border separating the turbulent river from the quiet pond has burst and water overflows as if pouring from one of Leonardo's pipes. Not even the irregular shapes of the reflected clouds are left undisturbed; cascading water distorts their finely focused images. In the opposite corner of the painting, the reflection of trees branches into roots, which form intricate fractal patterns. The reflections of the trees are partially obscured by a film of ice covering part of the pond. This surface on a surface also displays fractal patterns. Everything is in motion, nothing at rest: the ice melts and flows into the pond and the river surges over the edge, rushing toward the ice. In the apparently still waters of the middle, there is a clear image of billowing clouds. But darkness haunts these clouds; they appear to be thunderheads signaling an abrupt—perhaps catastrophic—change in the weather.

In the complex play of figures in *Water Lilies,* there are circles within circles and networks within networks. The most encompassing cycle is suggested by the circulation of solids (ice), liquids (water), and gases (clouds). Each of these conditions has a logic of its own, and yet all interact to form a complex system. Every system within this system is made up of seemingly countless microsystems. Ice shifts from chunk to film, and then gradually dis-integrates; water cascades, flows, and remains still; clouds morph as slight disturbances produce unexpected changes. The borders of these systems and processes mark the edge of chaos. When the point of self-organized criticality is reached, ice suddenly melts into water, water evaporates and drifts upward to become clouds that turn turbulent and suddenly transform gas into liquids (rain)

or solids (hail), which fall to the earth to begin their cycles all over again. The pulses of these cycles structure the painting. Moving left to right, ice becomes water; moving right to left, water becomes ice; in the middle, they mingle and ascend to the heavens, which, in the inverted image of the painting, is a descent to the depths. The structures of the painting, like the patterns of life, emerge from the interplay of cycles within cycles. In this way, the work of art not only represents but actually becomes a complex adaptive system.

As *Water Lilies* shows, Tansey finds in complexity theory a way to understand the intricate diversity of the networks within which we are forever caught. Different systems structured in different ways act and interact differently to produce the inescapable timely rhythms of life. The sites of these interactions are something like interfaces, which mark transitions between different phases of life. Life is neither totally ordered nor completely chaotic but is always lived at the edge of chaos. In figuring complexity, Tansey figures what can never be completely figured and thus must forever be refigured.

6 Transitions

Tansey's 1992 *Frameworks* suite includes a drawing entitled *Transition Team*. Though the mood of this work is somber, the picture is nonetheless reminiscent of *Mont Sainte-Victoire*. The drawing is structured like a grid with four quadrants. The dominant vertical axis is formed by a series of columns that seem to be supported by scaffolding. When placed in the context of the other drawings in this series, these columns appear to be a frame in the middle of the work. Along the horizontal axis, men and women, who are putting on or taking off their clothes, seem to be in a state of transition. At first glance, these figures seem to recall the men and women along the lakeshore in *Mont Sainte-Victoire* but, on closer inspection, important differences begin to appear. A sense of abjection pervades the work; the scene depicts the aftermath of a drunken orgy: empty bottles, trash, and other debris are strewn across a puddle that is too shallow and cluttered to bear clear reflections. Though intended to portray a state of transition, the picture is strangely static. The black-and-white image looks like a moment frozen in time by a snapshot taken with a 1950s Instamatic camera.

By the time Tansey completed the painted version of *Transition Team,* stasis has given way to motion as both structures and figures have become dynamic and complex. While the gridlike structure remains, it now serves to create a sense of motion rather than to fix movement. Anonymous figures

are replaced by recognizable characters: Madonna, John F. Kennedy Jr., Princess Diana, Drew Barrymore, and Kurt Cobain. Though the atmosphere of abjection persists, details of the work have changed significantly. Most important, the residual literalism of the drawing vanishes in the painting. No longer dressing and/or undressing, figures along the central horizontal axis now are engaged in a variety of activities. Here as elsewhere, a series of binary opposites structure the painting: void/form, empty/full, dark/light, wet/dry, human/animal, man/woman, tall/short, motion/rest, expansion/contraction, gravity/levity, and so on. Near the center of the work stands a woman who has not forgotten her umbrella. Next to her a man with a hard hat and shovel and a woman with a wheelbarrow are vainly trying to clean up the mess that has been created. To the left of these figures there is a man, with his back turned toward the viewer, who appears to be multiplying representations by photographing the scene with a small camera. The man who is running toward the center of the drawing from its right border has been replaced in the painting by a woman (Princess Diana) approaching from the right on horseback and another woman (Madonna) fleeing the site of abjection at the left edge of the work. Everything and everyone in the painting seem to be moving from right to left. As the eye traces this line of movement, the painting is actually transformed into a motion picture.

We have already discovered traces of movies in the screen on which *End of Painting* appears and in the filmlike quality of *Water Lilies*. While echoing these earlier works, *Transition Team* is considerably more complex. Not only are the figures depicted on the canvas captured in motion but the painting itself is in transition. Traces of this motion can be detected in the reflections appearing in the lower part of the painting. The images in the puddle are even stranger than the gender-bending reflections in the lake at the foot of Mont Sainte-Victoire. Rather than properly inverted reflections, the figures in the puddle are compressed versions of the representations above them. The transition from right to left repeats the transition from top to bottom or high to low. Proceeding from center to periphery, figures are compressed to the point of

disappearance. Conversely, moving from bottom to top and left to right, figures unfold until they assume recognizable proportions. The lower edge and left-hand border of the painting mark the site of the disappearance and appearance of the forms that constitute the work of art. Moving through a series of iterations from right to left, figures are squeezed through what looks like a stack of frames drawn from *Frameworks* until they are flattened into a series of parallel lines. When this process is reversed, lines gradually expand and morph into ostensibly "normal" figures. The only forms not misshaped are the birds whose flight lends the work of art a sense of levity and the bottles whose weight creates a sense of gravity.

In *Transition Team,* Tansey translates complexity theory into a complex artistic practice by pushing and pulling the *trait* of deconstruction in opposite directions. Less iconophobic than Derrida, Tansey not only works *at* the edge of representation but works *with* the edges of representations to create pictures that are richly figurative and constantly shifting. No longer merely the slim margin of difference that repeatedly withdraws, the zone of transition is the space and time where order repeatedly emerges from and returns to chaos. Complex adaptive systems, we have discovered, are open rather than closed. Putting theory to work in art, Tansey opens the painting to the space of the viewer and the time of viewing.

Transition Team activates vision by setting the viewer in motion. This picture is, in effect, an interactive work of art. In order to appreciate this painting, one cannot stand still but must view it from different angles. Moving around the picture, perspectives change until transitional spaces begin to vibrate, pulsate, and oscillate. Intersecting axes and contrasting figures combine to create alternating rhythms that trigger anomalous juxtapositions and unexpected dimensional shifts. As rippling patterns spread across the surface of the canvas, once still images become animated in a way that erases the line separating the formed from the deformed. Since every form is, from another point of view, anamorphic, everything is distorted, which, of course, is another way of saying that nothing is distorted.

The longer one ponders this painting, the clearer it becomes that Tansey has accomplished the seemingly impossible feat of inscribing an infinite number of perspectives within a finite space. In contrast to Cubism, which this strategy might seem to recall, Tansey is not interested in synchronizing viewpoints in a way that makes it possible to rise above them. To the contrary, he seeks to lure us ever more deeply into the flux of time and the gaps of space by drawing the viewer into the work of art and drawing the work of art into the field of the viewer. For this reason, the appreciation of Tansey's art not only *takes* time but *gives* time a different twist. Within his frame of reference, time is no longer a prison from which we seek to escape but is the vital medium of life itself.

By drawing viewer into picture and picture into viewer, Tansey folds the framework of the painting into the vision of the viewer. When we no longer merely look *at* Tansey's paintings but learn how to look through his works *with* him, we discover multiple ways to picture the world and ourselves anew. Like the complex systems he attempts to figure, Tansey's art represents an open-ended inquiry that is always in transition. Repeatedly putting the picture in question by ceaselessly probing the ends of representation, he creates a much-needed critical angle of vision from which to assess a world in which image and reality are rapidly becoming virtually indistinguishable. To *think with* Tansey is to *think about* things differently. As we are drawn into the work of art, we all become members of his *Transition Team* for whom *nothing* is fixed. If we were ever to get the picture Tansey is painting, we might begin to realize that the space of the medium is the time of life. We are forever destined to dwell on the edge of chaos where everything is in transition. Neither certain nor uncertain, neither secure nor insecure, life can, perhaps, be figured in the fleeting image of a cloud reflected in the rushing waters of a pond that once seemed still.

References for Paintings

Reproductions of Tansey's paintings can be found in the following books and catalogs:

Danto, Arthur C. *Mark Tansey: Visions and Revisions.* Ed. Christopher Sweet. New York: Henry Abrams, 1992. Hereafter cited as VR.

Freeman, Judi. *Mark Tansey.* San Francisco: Chronicle Books, 1993. Hereafter cited as MT.

Kellein, Thomas. *Mark Tansey.* Basel: Kunsthalle, 1990. Hereafter cited as MT2.

Sims, Patterson. *Mark Tansey: Art and Source.* Seattle: Seattle Art Museum, 1990. Hereafter cited as AS.

Visions of America: Landscape As Metaphor in the Late Twentieth Century. Denver: Denver Art Museum, 1993. Hereafter cited as VA.

Images of some of Tansey's works are available on the World Wide Web:

http://www.ecafe.com/artbridge/marktans.html

http://www.broadartfdn.org/bio-tansey.html

http://www.safran-arts.com/links/tansey.html

http://www.artseensoho.com/Art/MARCUS/tansey97/
tansey1.html

http:lonestar.texas.net/~mharden/archive/ftptoc/
tansey_ext.html

Locations for reproductions of some of Tansey's works:

"*a,*" 1990, VR 117; MT2

Achilles and the Tortoise, 1986, VR 96; *Artforum,* January 1987, p. 92

Action Painting, 1981, VR 43

Action Painting II, 1984, VR 62–63; MT2

The Bathers, 1989, VR 91

The Bricoleur's Daughter, 1987, VR 100; MT 27; AS 27

Bridge over the Cartesian Gap, 1990, VR 110–11; MT 52; MT2; VA 168; http://www.ecafe.com/artbridge/marktans.html; http.www.safran-arts.com/links/tansey.html

Charts and diagrams of questions, themes, and metathemes, 1986, 1989, MT 20–21, 24–25

Close Reading, 1990, VR 109; MT 29; MT2

Coastline Measure, 1987, VR 97; MT 37

Color Wheel, in collaboration with Fritz Buehner, 1989, MT 22–23; AS 10

Constructing the Grand Canyon, 1990, VR 122–23; MT 30–31

Derrida Queries de Man, 1990, VR 121; MT 43; http://www.safran-arts/com/links/tansey./html; http:/lonestar.texas.net/~mharden/archive/ftpotoc/tansey_ext.html

Doubting Thomas, 1986, VR 75; MT 36; *Artforum,* January 1987, p. 96; http://www.safran-arts.com/links/tansey.html

End of Painting, 1984, VR 67

Iconograph I, 1984, VR 73; MT 40

Incursion, 1990, VR 112–13; MT2

The Innocent Eye Test, 1981, VR 35; MT 56; MT2; http://www.safran-arts.com/links/tansey/html

J. Baptist Discarding His Clothes in the Wilderness (after Domenico Veneziano), 1990, VR 108

Judgment of Paris II, 1987, VR 55

The Last Judgment, 1971, AS 5; VA 168

Leonardo's Wheel, 1992, MT 63; VA 171

Mont Sainte-Victoire, 1987, VR 86–87; MT 55; *Art and Source,* pp. 22–23, MT2; http://www.safran-arts.com/

links/tansey.html; http://lonestar.texas.net/~mharden/
archive/ftptoc/tansey_ext.html

Myth of Depth, 1984, VR 58–59; MT 53

Preparatory studies for *The Bricoleur's Daughter,* 1985–86,
VR 101–3

The Raw and the Framed, 1992, MT 84; http://www.safran-arts.com/links/tansey.html

Reader, 1990, VR 119

Robbe-Grillet Cleansing Every Object in Sight, 1981, VR 37;
MT 38; MT2; VA 170

A Short History of Modernist Painting, 1979–80, VR 33; *AS,*
p. 15; MT 15

A Short History of Modernist Painting, 1982, VR 39

Transition Team, 1992, MT 88

Triumph of the New York School, 1984, VR 50–51; MT 44–
45; MT2; http://www.safran-arts.com/links/tansey.html

Under Erasure, 1990, VR 115

Valley of Doubt, 1990, VR 106–7, VA 169

Water Lilies, 1994, VA 230–31

White on White, 1986, VR 78–79; MT 41; *AS,* pp. 18–19

Index

Silk-screening, 34, 64, 79
Singularities, 114
Smithson, Robert, 39
"Solving the Mathematical Riddle of Chaos" (Gleick), 107
Space, 77, 78, 106
 See also Gap; Rift; Time
Spurs: Nietzsche's Styles (Derrida), 84, 85, 86–87, 90, 92–93
Structuralism, 4–5, 49–51, 56–57, 83–84, 85, 88
 and frames, 60–61
 shortcomings of, 99–100, 119
 See also Binary opposition; Lévi-Strauss, Claude
Structural Morphology and Morphogenesis (Thom), 112–13
Surface, 64, 107

Tansey, Mark
 and Derrida's aversion to painting, 75–76
 and expanding beyond the "narrow present," 25–26
 his criticism of modernist painting, 38–40, 66, 75
 historical context of his early painting, 3–4
 and image versus text or idea, 34, 43, 49
 and meaning, 41–62
 on representation, 23–27, 34–35, 42, 96
 paintings of, inclusion in The Picture in Question, xi
 and producing of paintings, his method of, 30, 53
 training of, 4–5
 See also Layering
Tansey, Richard G., 30–31
Taylor, Mark C., his own work, x
Technophor, 54n
Temporality
 and the grid, 37, 57
 in Tansey's paintings, 26, 28, 29, 31–32

Textual absorption in Tansey's paintings, 78–81
Texture in Tansey's painting, 32, 64, 76–77, 78–79
 See also Layering
"Thing, The" (Heidegger), 20
Things, in phenomenology, 19–20
Thom, René, 112–13, 114–16
Thompson, D'Arcy, 113
Time
 and complexity theory, 119–20
 as the medium of life, 132
 and Minimalism, 12
 and nonlinear dynamic systems, 114
 Plato's conception of, 9, 12, 21, 114, 119
 and representation, 24
 and space, 77, 78
 and structuralism, 57, 119–20
Titles of Tansey's paintings, 1–2
Topology, 113–14
Trace, 76–78, 95, 106
Trait, 73, 74, 95–96, 106, 131
Transition Team (painting), xii, 129–30
Triumph of the New York School (painting), 2–3
Triumph over Mastery II (painting), 36n
Truth in Painting, The (Derrida), 58, 59, 68, 88, 93
"Twists of Space" (Peterson), 109–10

Umbrella, 87n, 87, 90, 91–94, 102
Under Erasure (painting), 64–65, 76–77, 78, 79

Valley of Doubt (painting), 79, 81
van Gogh, Vincent, 93, 94
Visible and the Invisible, The (Merleau-Ponty), 19, 88

143